A SECOND LOOK

A photographic record of a walk through
Hackney in the 1890's and today

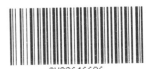

Published by Centerprise Trust Ltd

¼ MILE

N

RIVER LEA

MOUNT PLEASANT HILL

PLEASANT LANE

MOUNT

SPRING LANE

50

51

52

49 48

SPRING HILL

SPRINGFIELD

JESSAM AVE

MORESBY RD

WARWICK GRO

SOUTHWOLD RD

GUNTON RD

CLEVELEYS RD

37

40

41

42

43 44

UPPER CLAPTON ROAD

38 39

NORTHWOLD RD

EVERING RD

ICKBURGH RD

CAZENOVE ROAD

FILEY AVE

CHARDMORE RD

FORBURG RD

OSBALDESTON RD

OLDHILL ST

45

46 47

Guide to walk based on map copyright G W May Ltd

This collection of photographs follows up our
first collection, *A Hackney Camera*, which we
published last year and which attracted enormous
interest locally. This time we have matched each
old photograph with a contemporary photograph
of the same scene, and also arranged them in the
order of a walk which is detailed on the map on
pages 2 and 3. At the back of the book is a map
of the same area in the 1870's.

We would like to thank three people particularly
for making this book possible. Firstly Mr H Rapson
for allowing us to make copies of the old photo-
graphs in his possession. Also Mr I Renson for
identifying the exact location of each photograph
and providing the notes that accompany each one,
and finally Michael Silve, a sixth-form student at
Clissold Park School for providing us with the
modern photographs.

We continue to collect and copy old photographs
as a record of the past and hope that readers who
have photographs in their possession, or who
know of others who have such photographs, will
allow us to make copies, possibly for future
publications. In the meantime, we hope this
collection will provide interest and enjoyment,
as well as reminding people of the importance
of keeping a careful eye on the quality of the
surroundings in which we live.

Ken Worpole
Centerprise Trust Ltd

First published 1975 by Centerprise Trust Ltd,
which acknowledges the financial support for
its publishing activities from the Greater London
Arts Association and the Hackney Borough
Council.

Copyright © Centerprise Trust Ltd 1975

Early photographs kindly lent by Mr H Rapson.
Contemporary photographs taken by Michael Silve.

Designed by Peter Gladwin
Printed by Expression Printers Ltd, London N1

ISBN 0 903738 18 X

A SECOND LOOK

A photographic record of a walk through
Hackney in the 1890's and today

Accompanying notes by Mr I. Renson.

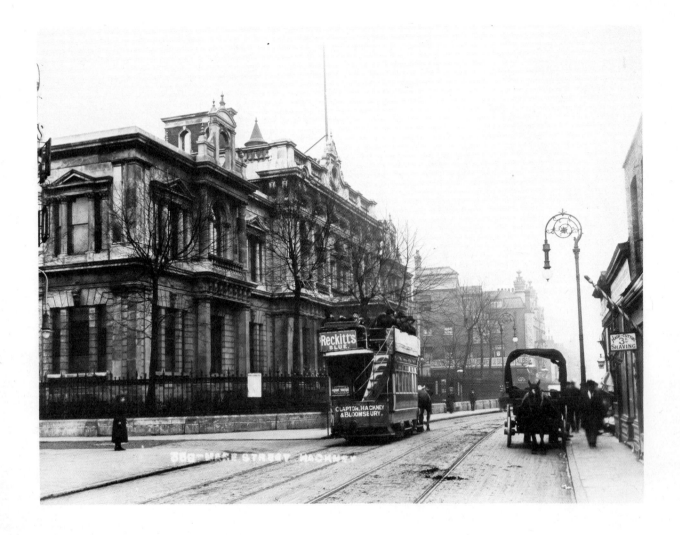

Hackney's second Town Hall, completed in 1866.
Taken from the corner of Paragon Road, in the
autumn or winter; the lime trees are quite leafless.
This Town Hall was built on the former Hackney
Grove, an open space at one time used as a paddock
for sheep by local butchers. It cost £18,000. The
wings were added in 1896 at a cost of £11,000.
It was demolished after the present Town Hall, built
behind it, was opened in July 1937. The site is now
laid out as an ornamental garden. Date, about 1906.

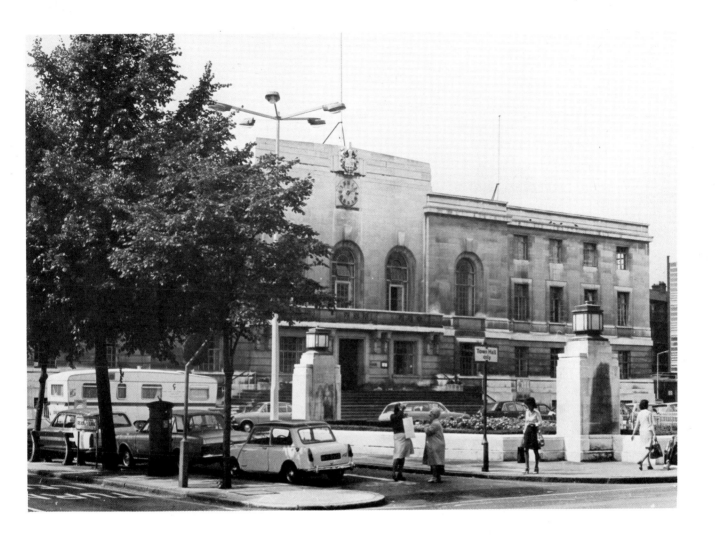

1

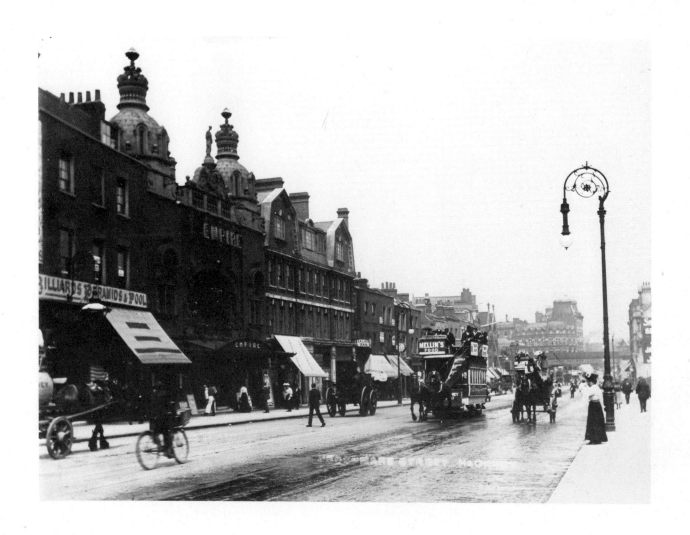

The west side of Mare Street, from the Britannia public house to Hackney Station. Taken from outside the present Hackney Central Hall, in the summer. Date, about 1906.

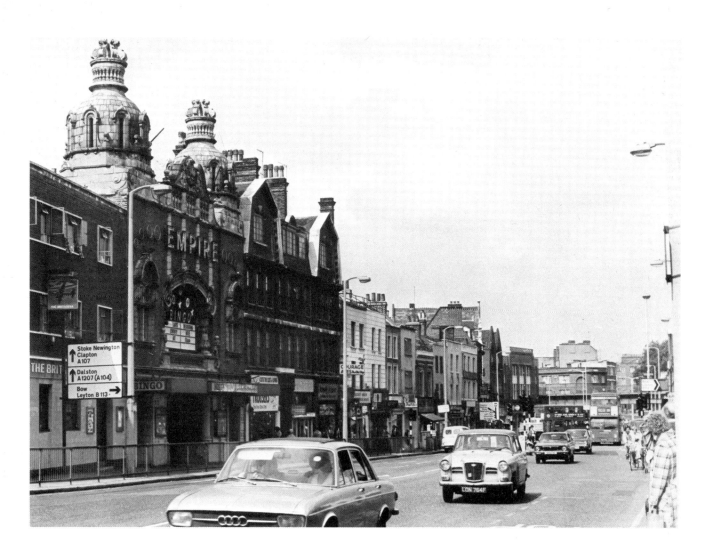

2

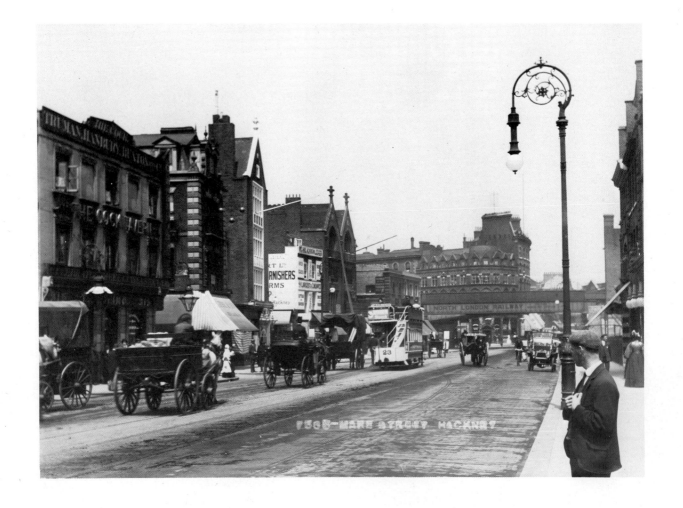

The west side of Mare Street, from the Cock Tavern to Hackney Railway Station railway bridge. Taken from the north corner of Morning Lane, about the same time as the previous photograph. Date, about 1906.

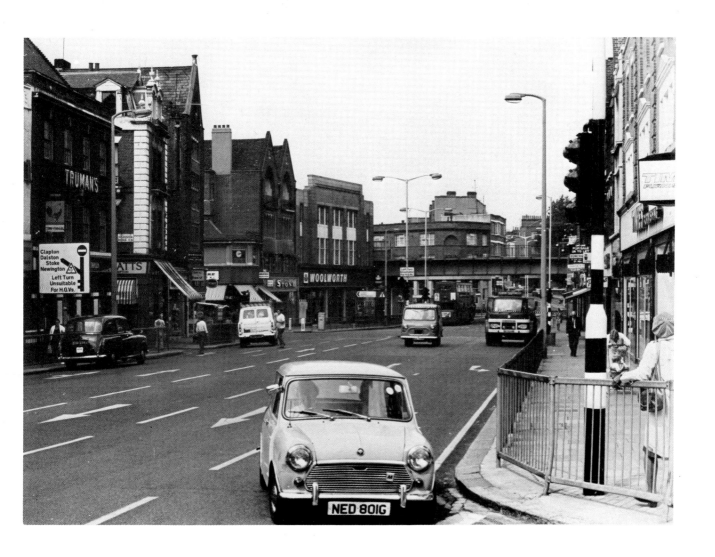

3

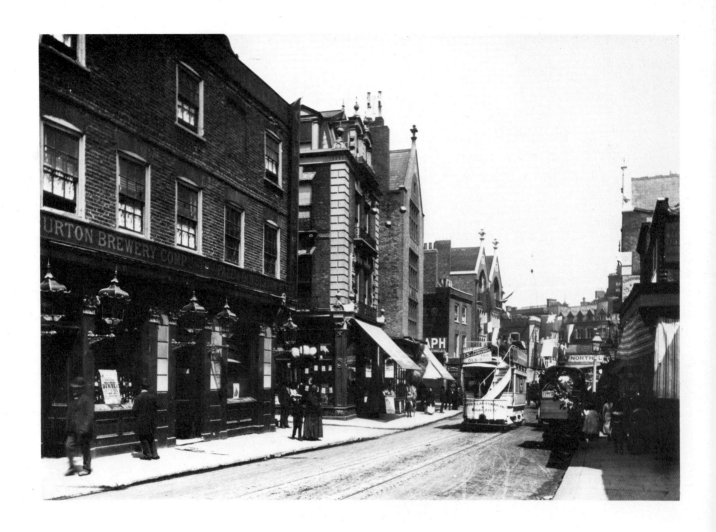

The west side of Mare Street, from the Cock Tavern
to Hackney Station railway bridge. Taken from
the north corner of Morning Lane, from almost the
same spot as the previous photograph, about twenty
years earlier, but the road was then very much
narrower, in fact only as wide as the present Narrow
Way. Date, 1887 in midsummer, when Queen Victoria's
fiftieth anniversary Jubilee was being celebrated,
hence the flags.

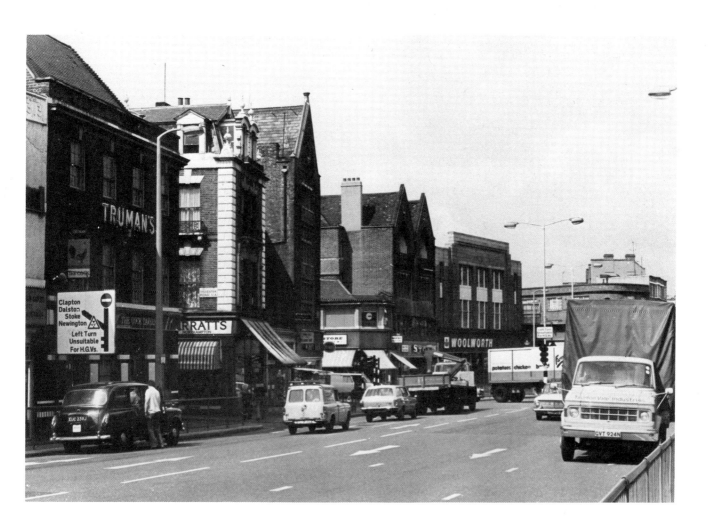

4

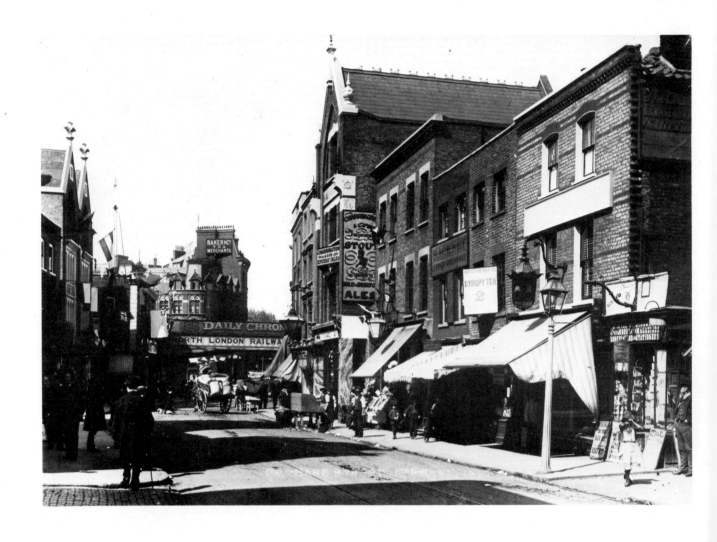

The east side of Mare Street, from a little north of
Morning Lane to Hackney Station railway bridge.
Taken from the south corner of Sylvester Road,
outside the Cock Tavern, about the same period as
the previous photograph but in the late afternoon,
judging from the long shadows cast by the westerly
sun. Date, 1887.

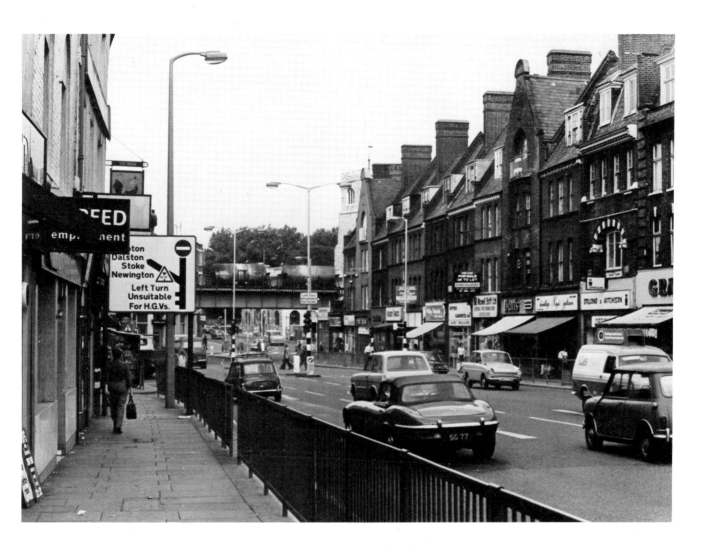

5

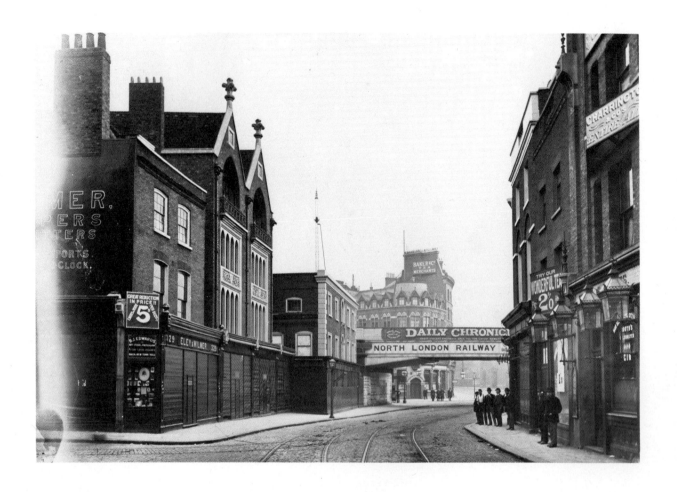

Mare Street, junction with Graham Road, looking north towards Hackney Station; taken from the middle of the road, halfway between Morning Lane and the railway bridge. The road was widened in 1904. Date early 1880's (on Sunday or early morning in the autumn or winter).

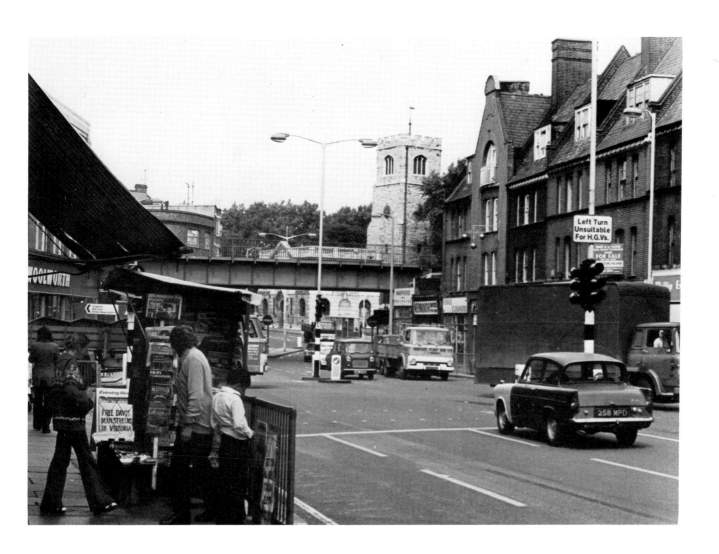

6

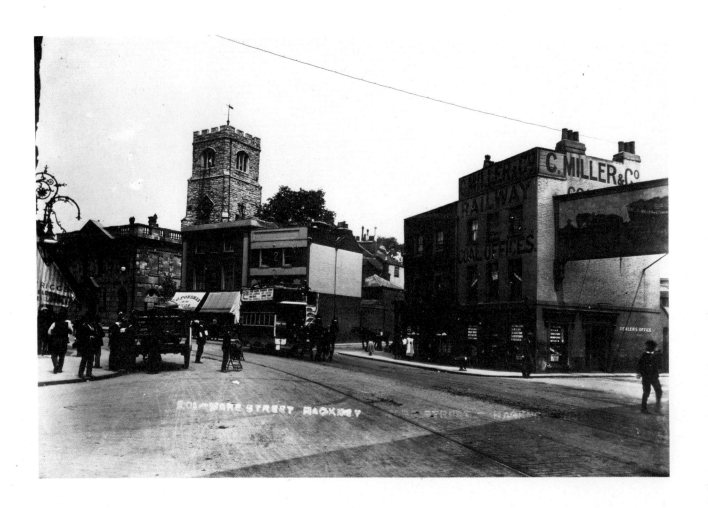

Hackney Tower and Old Town Hall (since 1899, the
Midland Bank), the Beehive and Bohemia Place,
Brodribb, chemist, and C. Miller & Co, coal merchants,
taken from the south corner of Amhurst Road, just
under the railway bridge. Only the Tower and the
bank survived bombing in World War Two. Date
1908 (in summer).

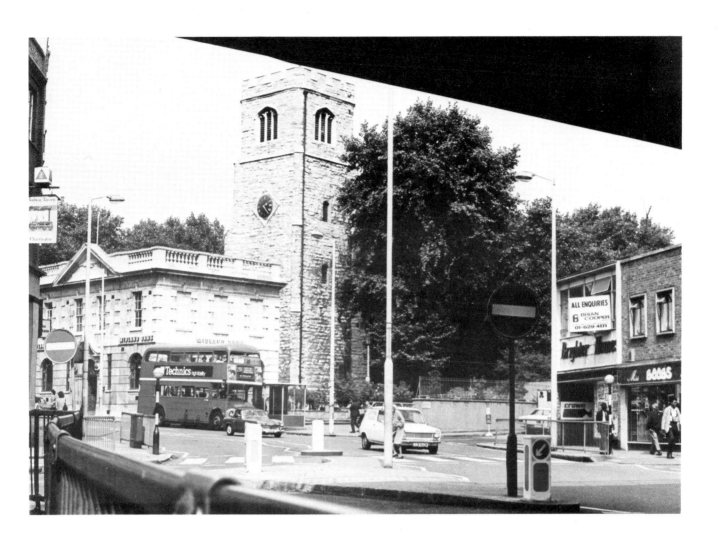

7

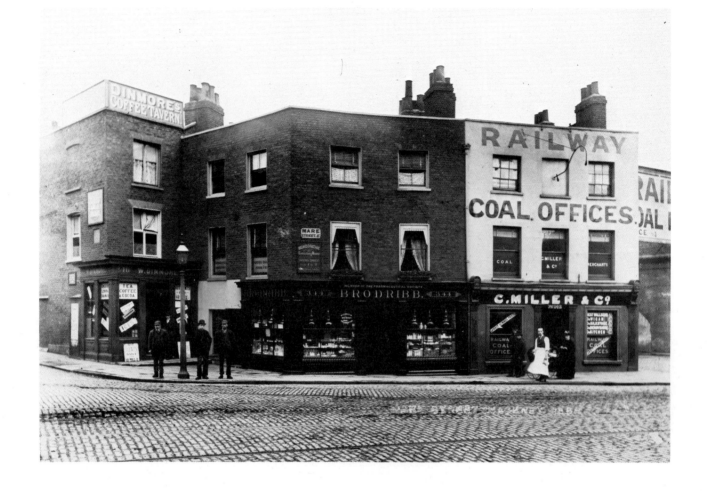

Dinmore's Coffee Tavern, Brodribb, chemist, and C. Miller & Co, coal merchants, at the corner of Bohemia Place, taken from the Railway Tavern. The tramway depot at the end of Bohemia Place is now Clapton Bus Garage. Date 1888 (in summer).

8

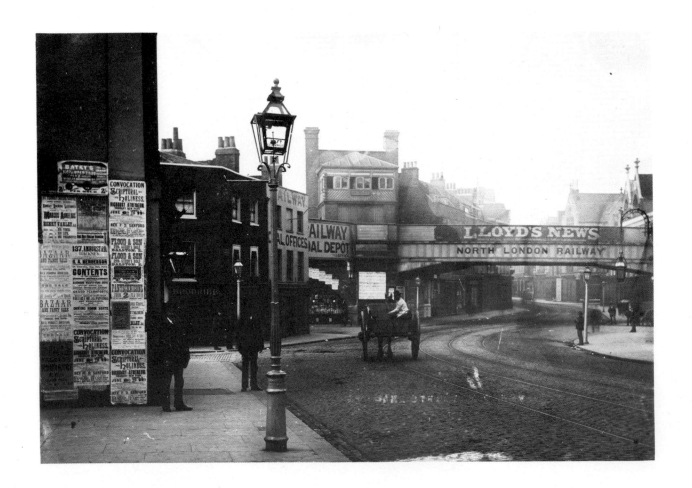

Mare Street, looking south, taken from the Old Town Hall (now Midland Bank). The beehive, for many years a tailor's shop, is on the left on the site of the present St John's Gardens. Date early June 1887 (on Sunday or early morning).

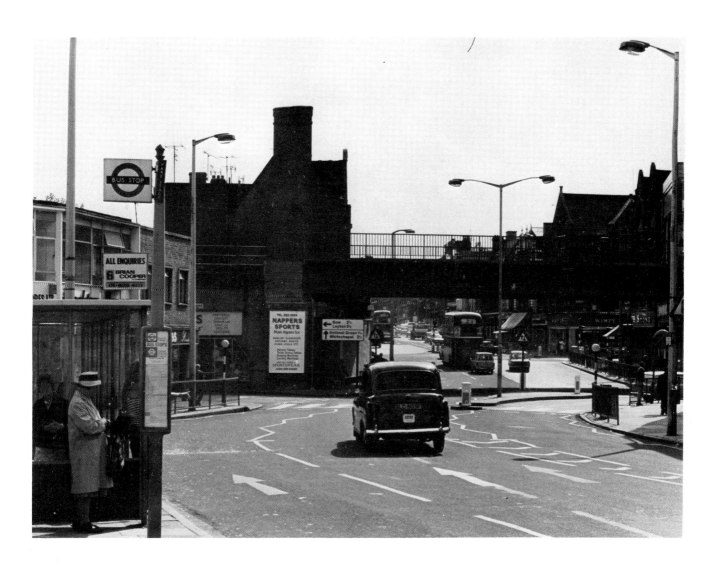

9

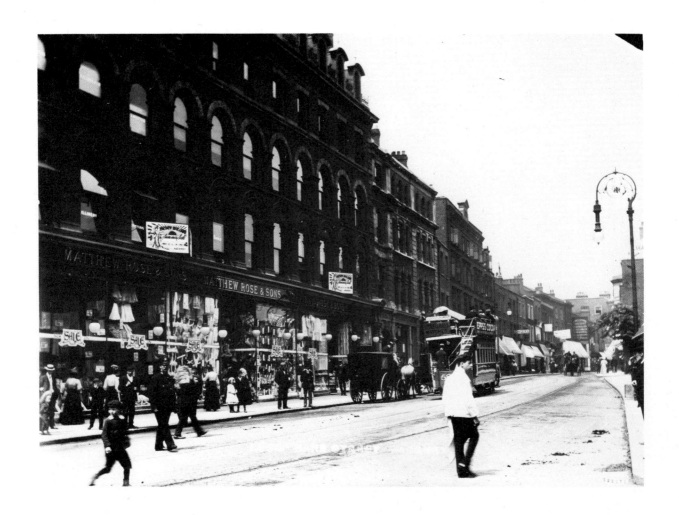

Mare Street. The Narrow Way, looking north, taken from Bohemia Place south corner. Matthew Rose and Sons, drapers and outfitters, advertise a Summer Sale during July. Marks and Spencer occupies most of the site today. The National Penny Bank building, next door, still remains, as Domus, the Co-operative store. Date about 1908 in summer.

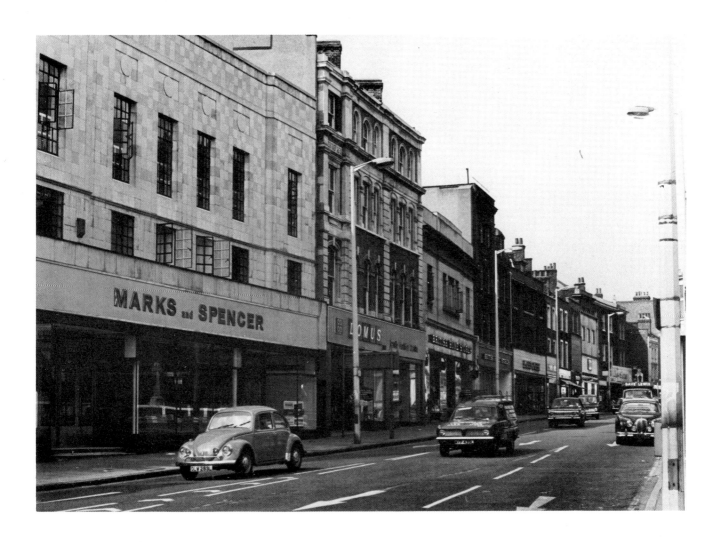

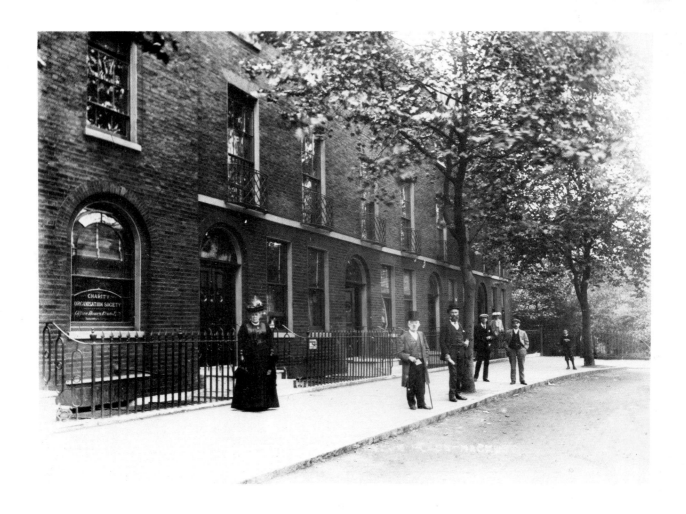

Sutton Place. South side, numbers 1 to 5, looking west towards the churchyard, taken from about halfway along the road. This side of the road was built about the first decade of the 19th century, and is unchanged except for the trees which have gone. Date about 1908 in summer.

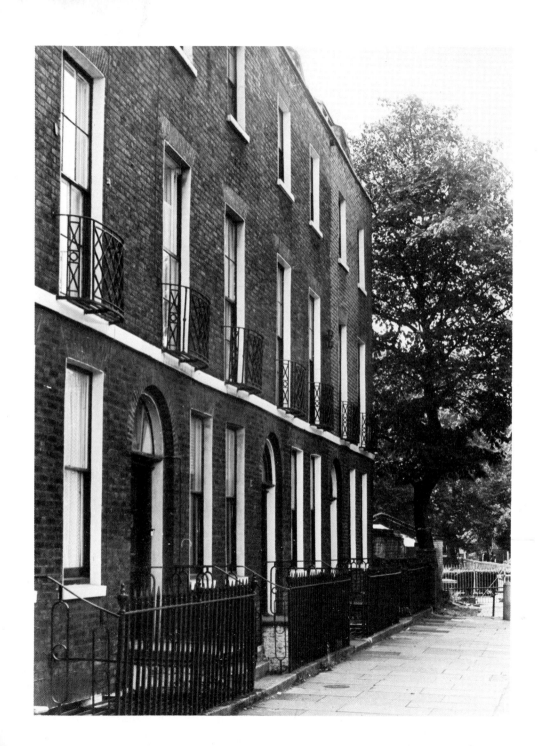

11

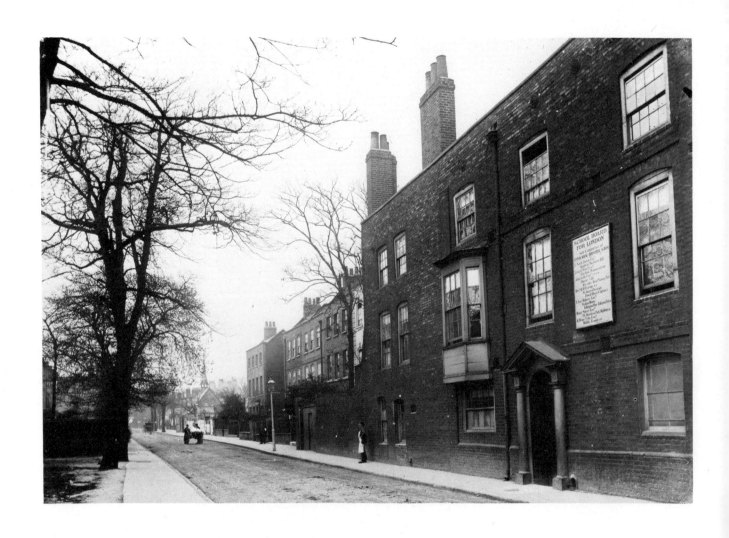

Upton House Industrial School, Urswick Road,
Homerton, looking north (the spire of Ram's School
in the distance), taken from near the north corner of
Sutton Place. Urswick Road was formerly called
Upper Homerton. Date about 1880 (in the winter).

12

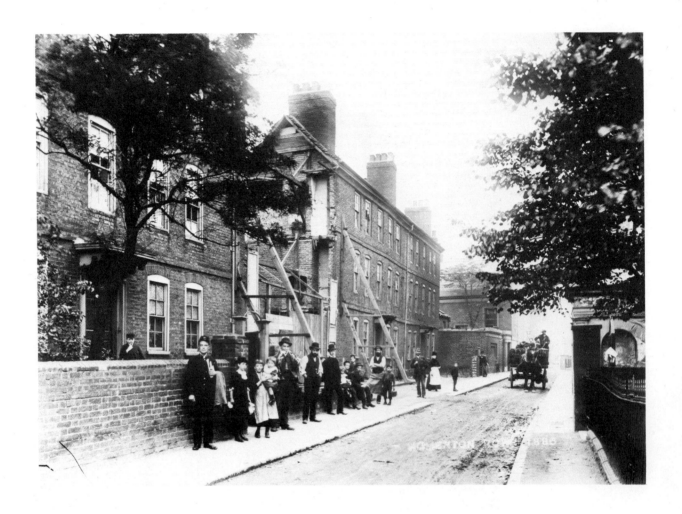

*Homerton Row (formerly Alderman's Walk), the
north side, looking east, taken from what is now the
entrance to Upton House Comprehensive School.
The houses probably dating from the reign of
George I were demolished shortly after. The site is
now occupied by recently built council houses.
Date 1886 (summer).*

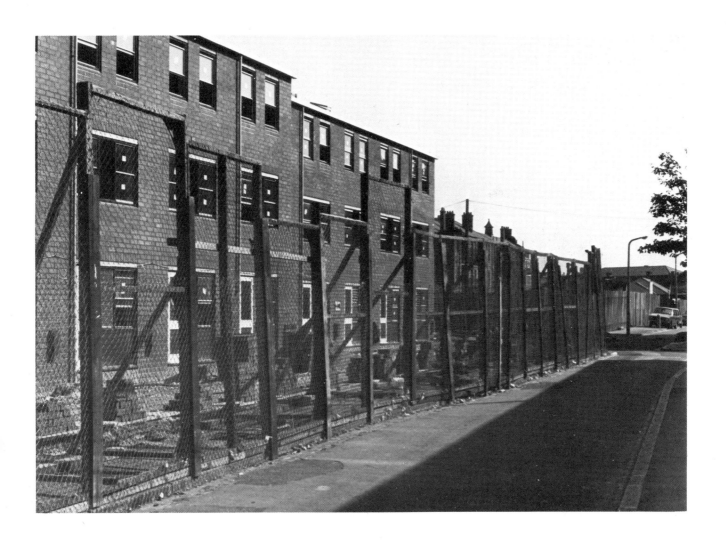

13

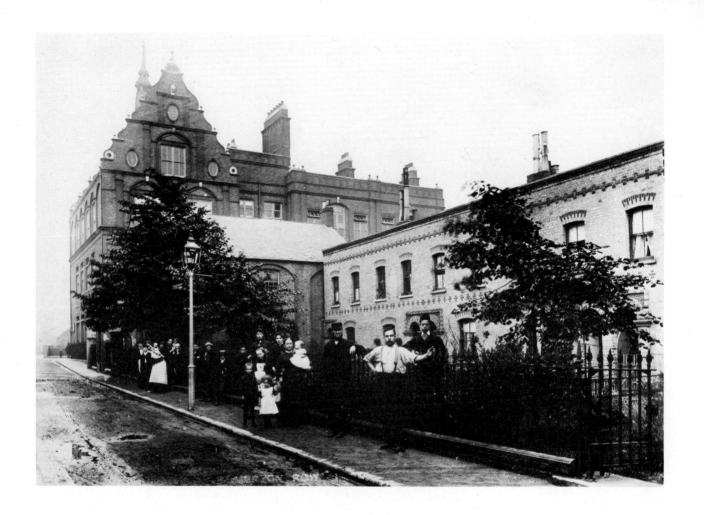

*Homerton Row, the south side, looking east, the
whole of which is now occupied by Upton House
Comprehensive School, taken from opposite the
present entrance. Homerton Row School, then quite
new, stood on the corner of Furrow Lane (formerly
Plough Lane). Date 1893, summer.*

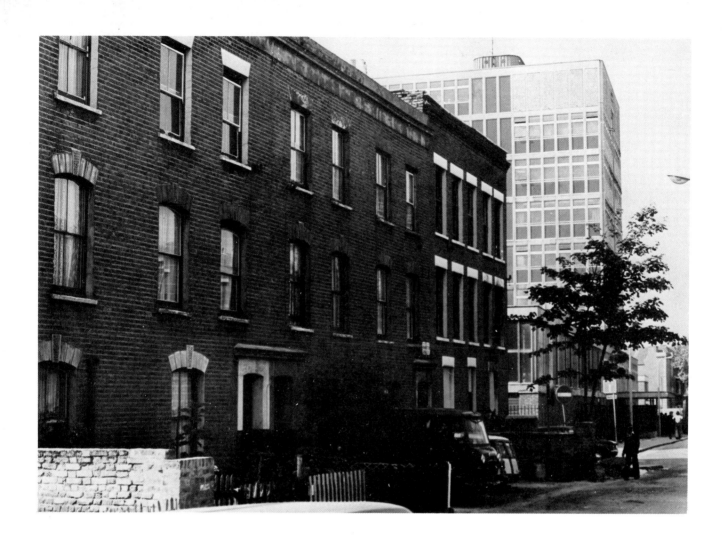

14

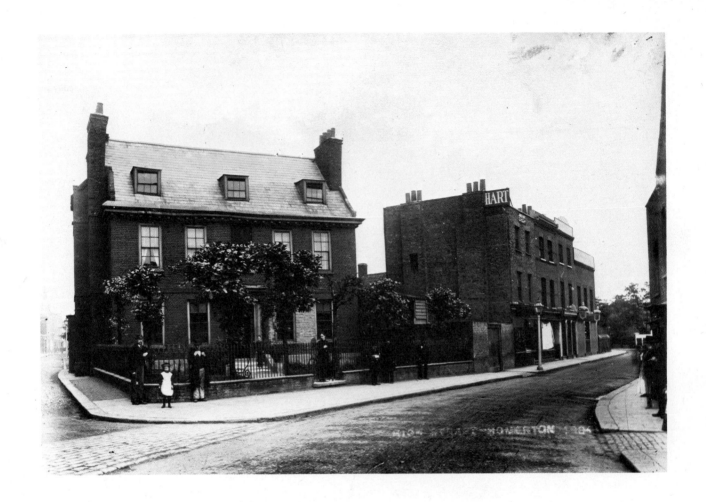

Homerton High Street, junction with Homerton Row, looking south, taken from outside Sutton House on the corner of Isabella Road. Eagle House, then occupied by a dyer and bleacher, in its last days became a lodging house for men and was demolished after World War Two. The Upton House School caretaker's house now stands close to the site. Date 1884, summer.

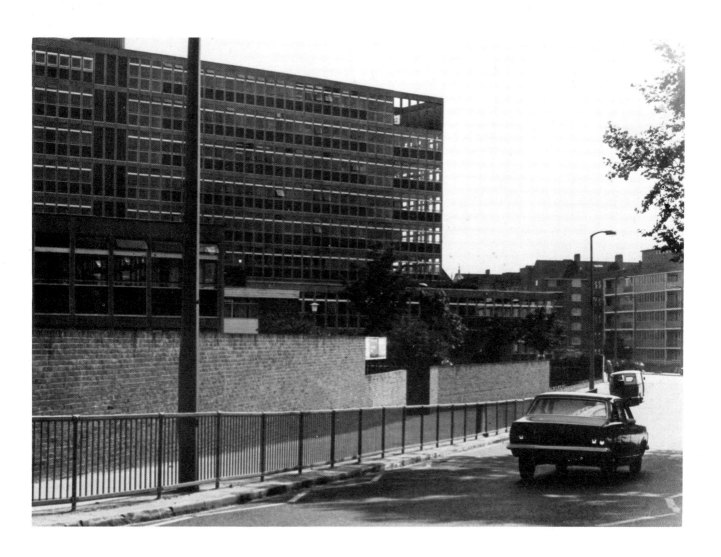

15

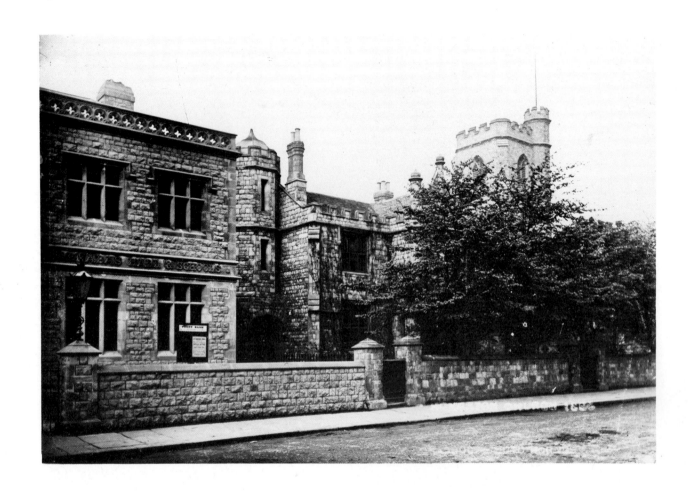

Saint Barnabas Church, Vicarage, Hall and Schools,
Homerton High Street, corner of Brooksby's Walk;
taken from the north corner of Mackintosh Lane.
The Hall and Schools were then recently built.
There is today little change, the turret and cupola
between the Vicarage and Hall have given way to a
garage. Date 1884, summer.

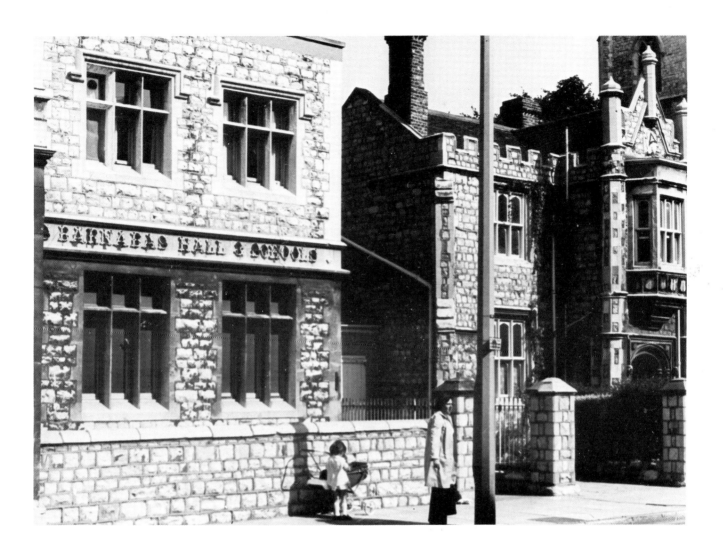

16

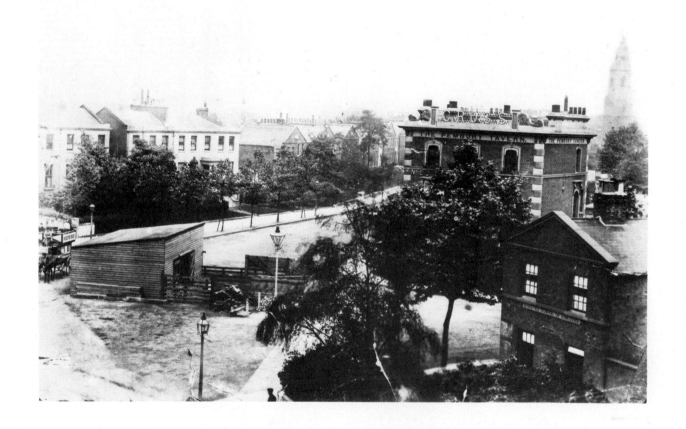

*The Pembury Tavern at the junction of Amhurst
Road and Dalston Lane, looking east, taken either
from the Hackney Downs Station railway bridge or
from the top-floor window of the house in Dalston
Lane, adjacent to it. Hackney School of Industry,
the forerunner of the Hackney Institute, now
Technical College, is in the lower right corner.
Date about 1893 in summer.*

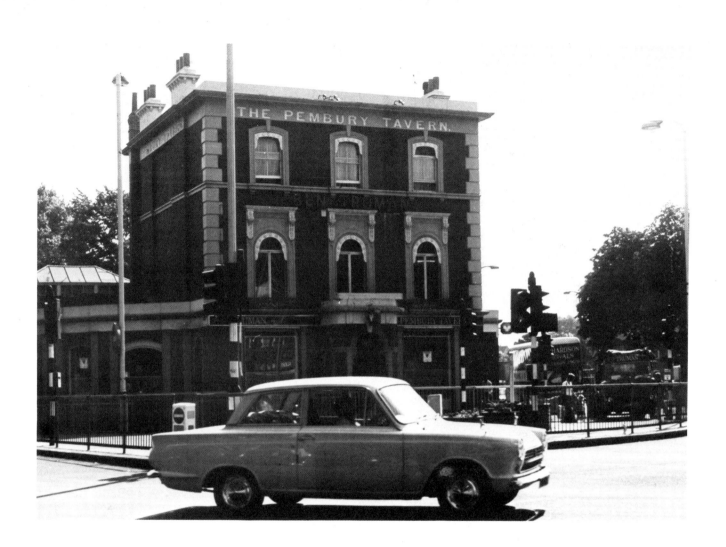

17

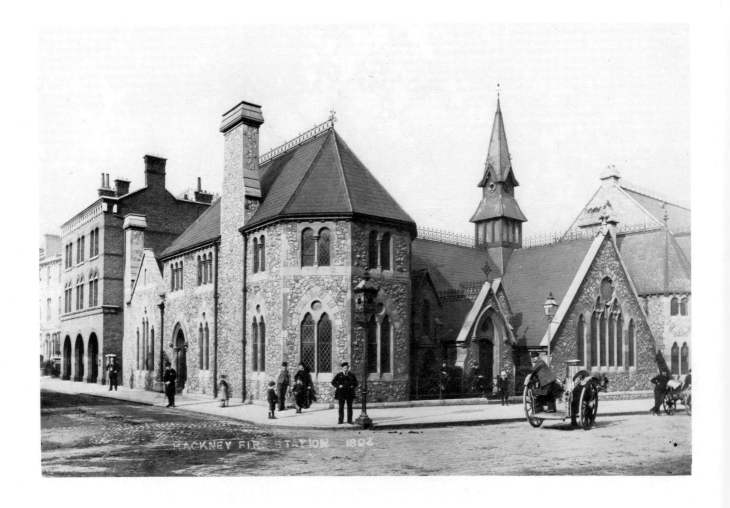

HACKNEY FIRE STATION 1802

Hackney Fire Station and Lower Clapton Congregational Church, Hall and School, at the corner of Amhurst Road and Bodney Road, taken from under the railway arch in Amhurst Road. The latter buildings were replaced in 1938 by Downs Court, the flats and shopping parade facing the Pembury Tavern. The fire station, an entirely different building today, the upper part converted into flats (Bodney Mansions) now serves as a garage. Date 1893 in the summer.

18

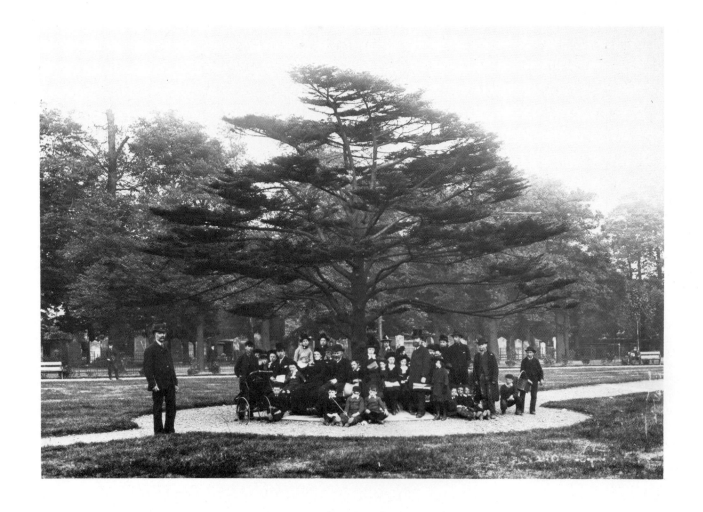

*St John-at-Hackney Churchyard, now known as
St John's Church Gardens, looking east towards
St John's Church Road, the church being at the
end of the path on the right. The Lebanon cedar
has now been replaced by a war memorial and
there are flower beds on the lawns. Date about
1884 in the summer.*

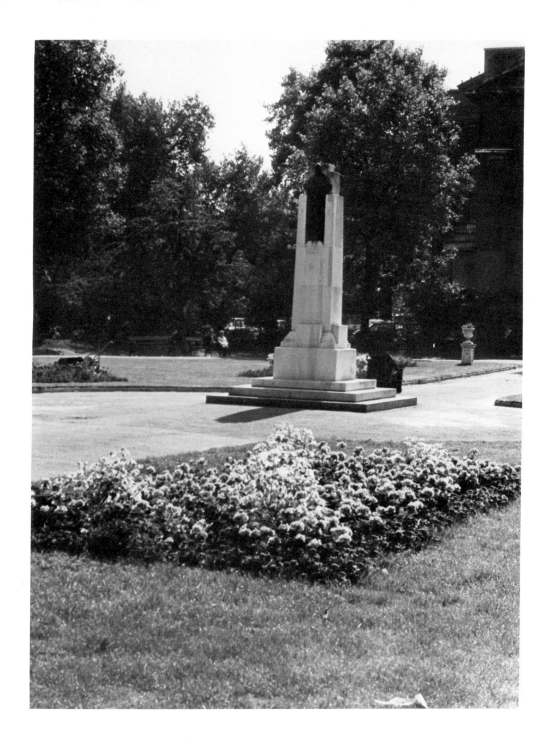

19

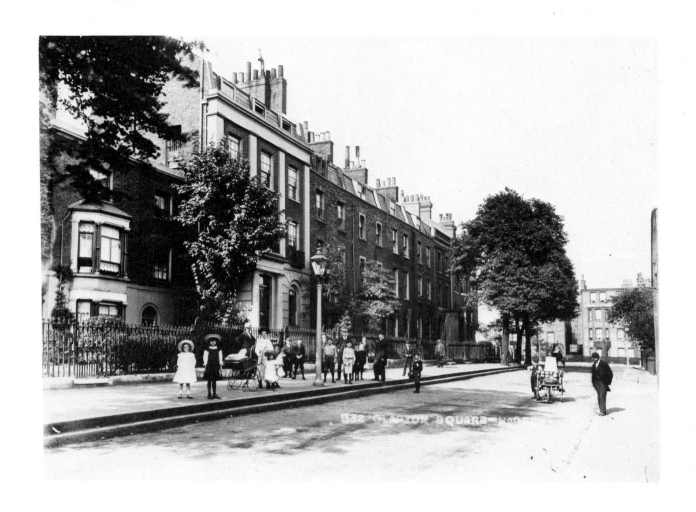

Clapton Square, the north side looking east towards Clapton Passage from Clarence Place. There is comparatively little change the chief difference being the absence of the railings. Date about 1906 (summer).

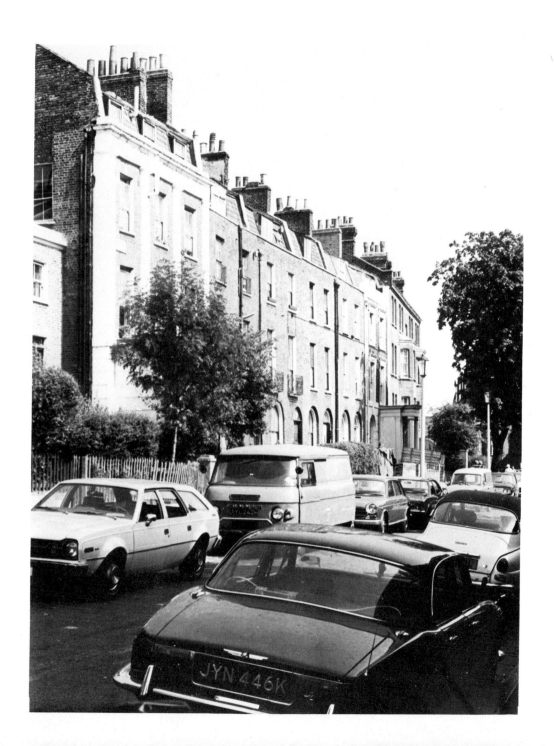

20

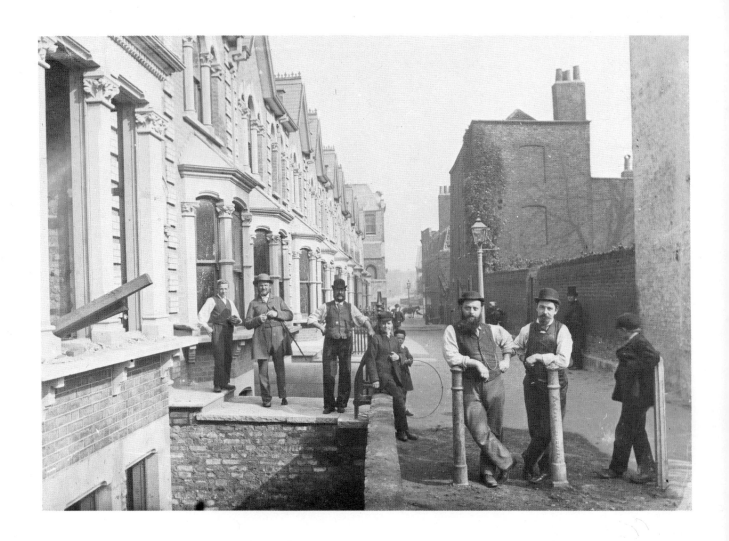

Clapton Passage, at the north east corner of Clapton
Square leading eastward to Lower Clapton Road.
The houses on the left known as Holly Villas still
existing, were then in the course of construction.
The house and wall on the right are now replaced
by two-storey houses called Ivy Villas. Date 1882
in summer.

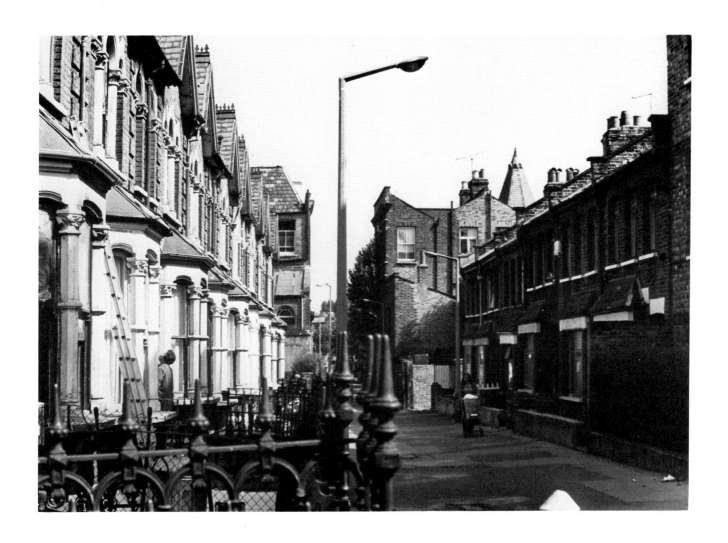

21

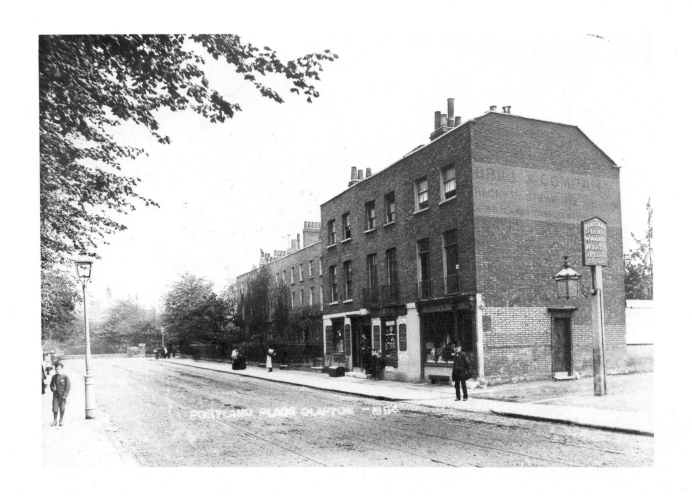

Portland Place, Lower Clapton Road, a terrace of shops and houses, extending from Hackney Church yard to Urswick Road (Upper Homerton), taken from the south east corner of Clapton Square, looking east. It has been completely replaced by Hackney Police Station (built 1904), the London Electricity Board Offices and intervening houses with portico entrances at the top of steps. The change is remarkable, if not unbelievable, so unrecognisable is the area. Date summer 1884.

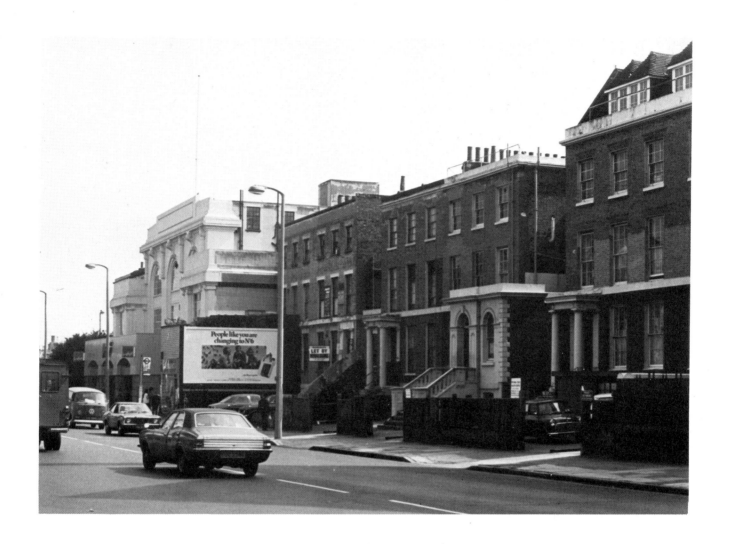

22

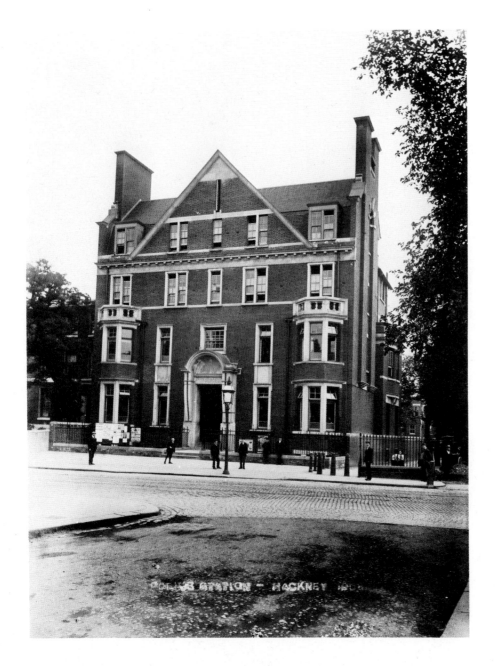

*Hackney Police Station, Lower Clapton Road, taken
from Clapton Square, south east corner. Built in
1904 the building is unchanged. Date 1906, summer.*

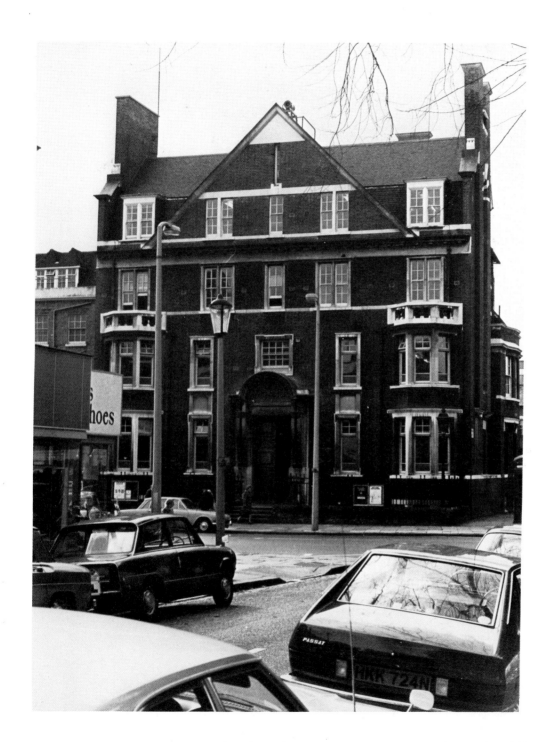

23

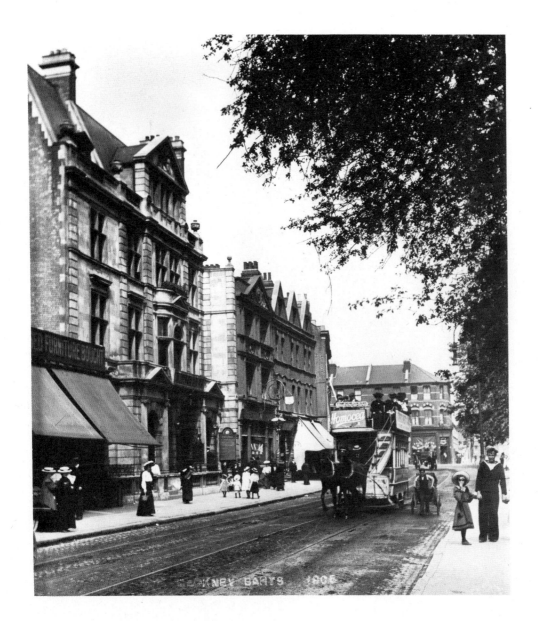

*Hackney Baths (King's Hall), Lower Clapton Road
taken from Hackney Police Station, looking east
to the corner of Lesbia Road. There is little change.
Lesbia Road and the shops adjacent have been
demolished for redevelopment by Hackney Borough
Council, and there are no longer trees on the right.
Date 1905, summer.*

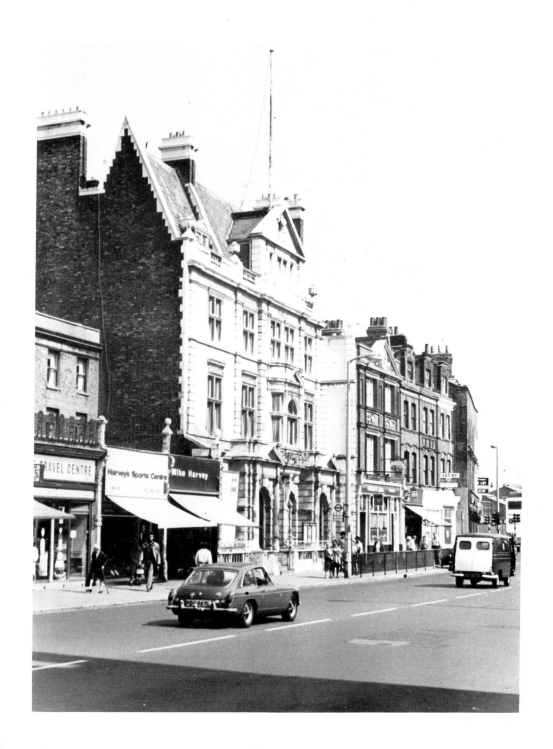

24

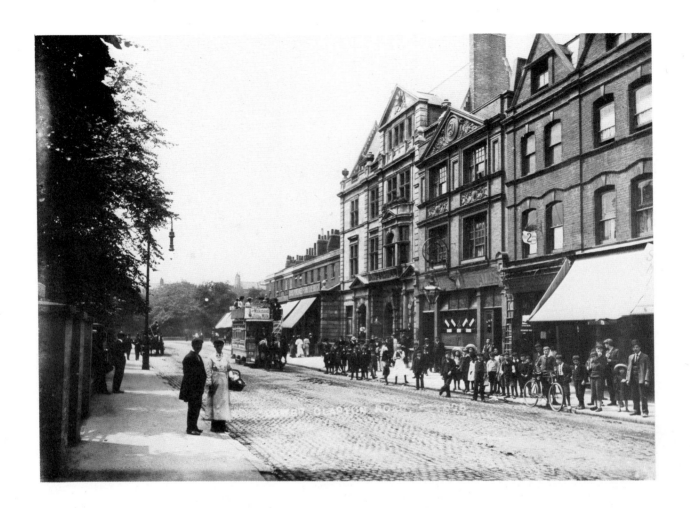

Hackney Baths (King's Hall), Lower Clapton Road, taken from near the corner of Urswick Road, looking west towards Clapton Square. Little change has taken place in the buildings, the Elephant's Head public house having been recently redecorated in bright colours. Date 1905, summer.

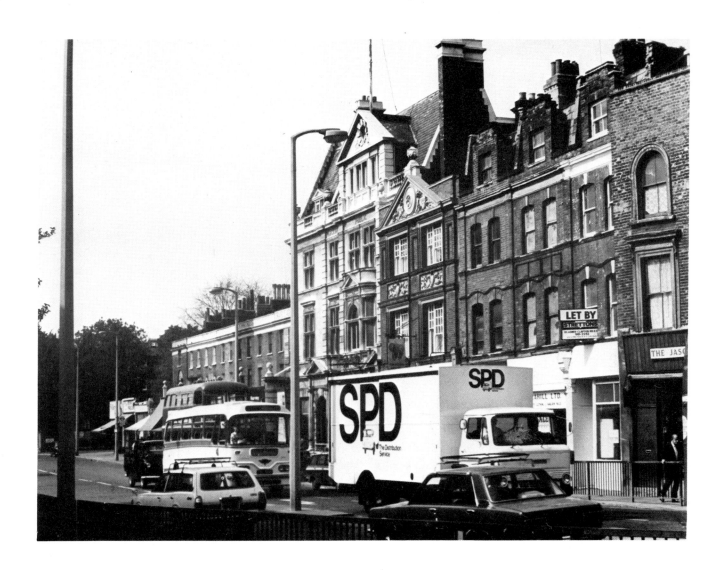

25

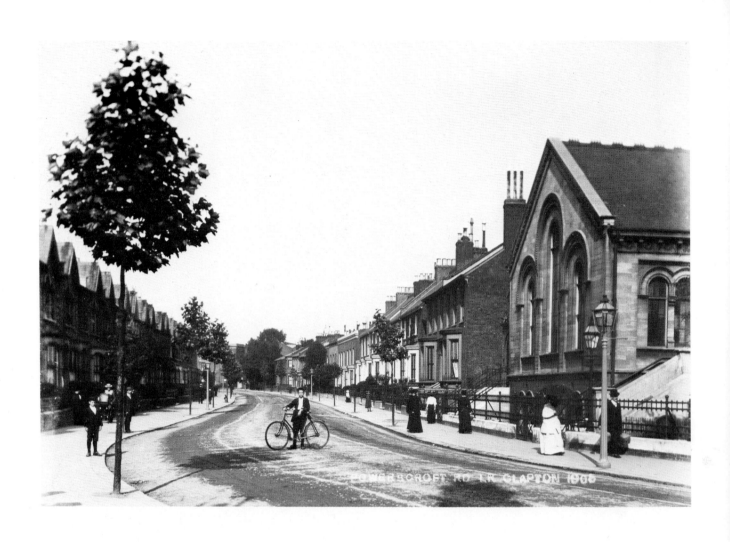

Powerscroft Road, Lower Clapton Road, looking east from the north corner of Clapton Passage, the north wing of the Round Chapel (Clapton Park Congregational, now United Reformed Church) on the right. It is virtually unchanged, but the trees have grown considerably. Date 1905, summer.

26

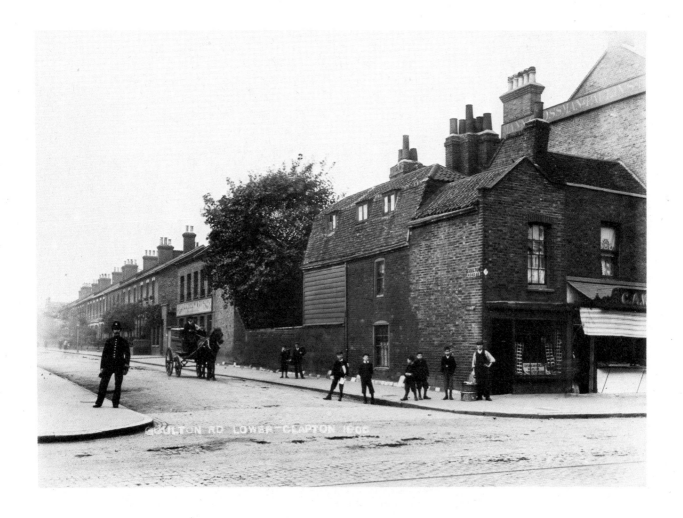

Goulton Road, junction with Lower Clapton Road,
taken from near Linscott Road looking west. The
whole corner, demolished by bombing during World
War Two, is now an open site used as a car mart. The
Windsor Castle public house, on the right, still
stands. Date 1906, summer.

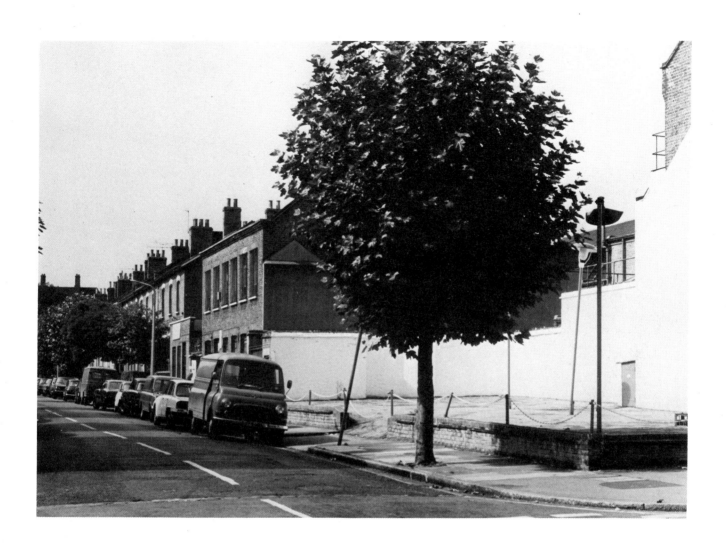

27

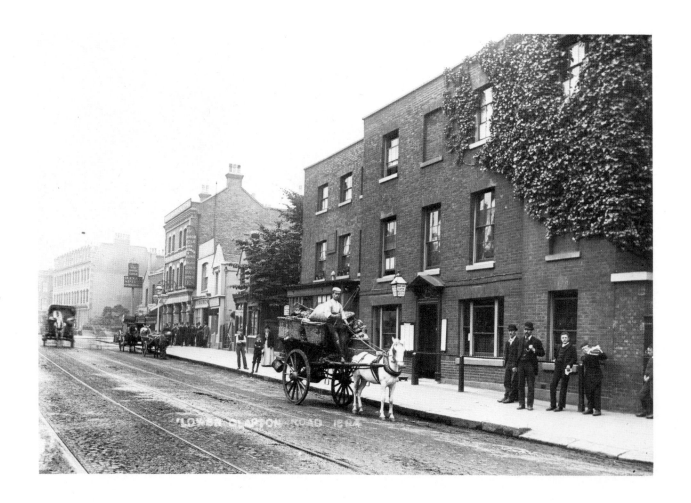

Priory House (then the Clapton Registry Office),
Lower Clapton Road, taken from near the south
corner of Laura Place, looking south. This early
18th century house, still known to the occupiers
by its original name, is now partly florists and partly
building contractors. The Salvation Army Mothers'
Hospital is to the right of the house in the picture.
A registry office was then the equivalent of an
employment agency. Date 1884, summer.

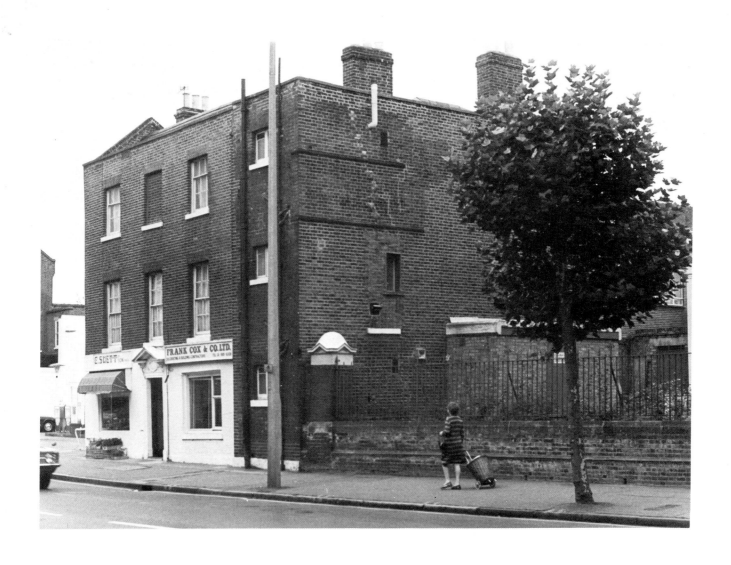

28

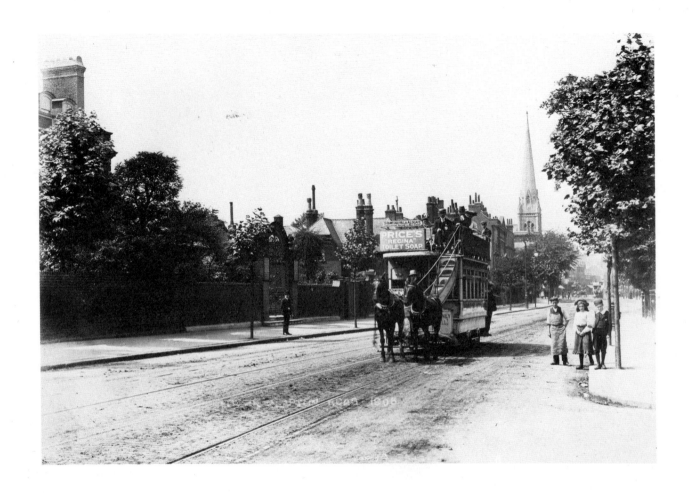

Lower Clapton Road, from the south corner of Atherden Road, looking north toward Downs Road and Clapton Pond. The early eighteenth century British Asylum for Deaf and Dumb Females and the low houses on the left almost up to Downs Road have been replaced by Powell House council flats. The Clapton Wesleyan Chapel, whose steeple can be seen in the distance gave way many years ago to a row of shops facing Clapton Pond. Date 1906, summer.

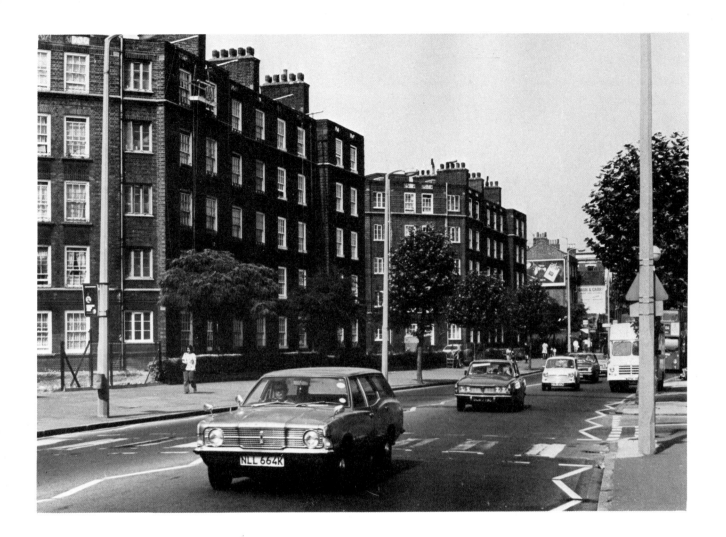

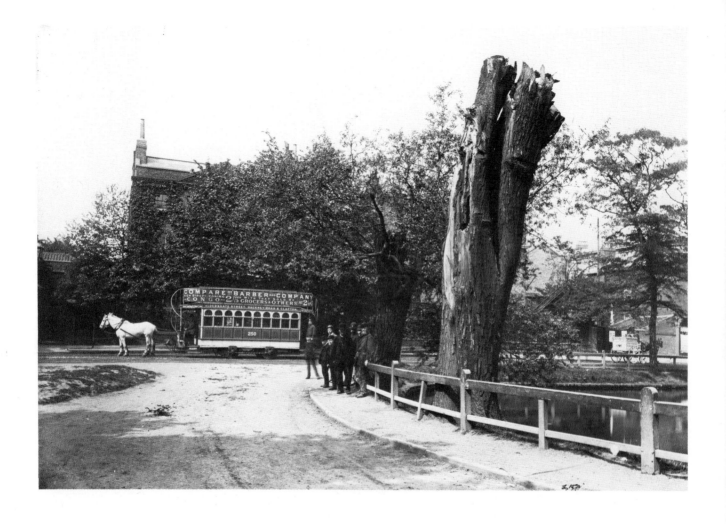

Clapton Pond, at junction of Millfields Road (formerly Pond Lane) and Lower Clapton Road, looking west. Much changed today, the pond has iron railings and the large house opposite, is replaced by part of Powell House flats. Date about 1885 in summer.

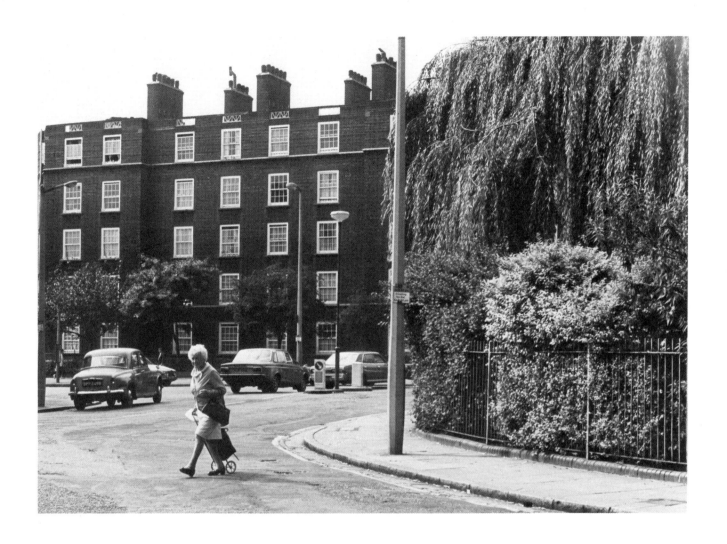

30

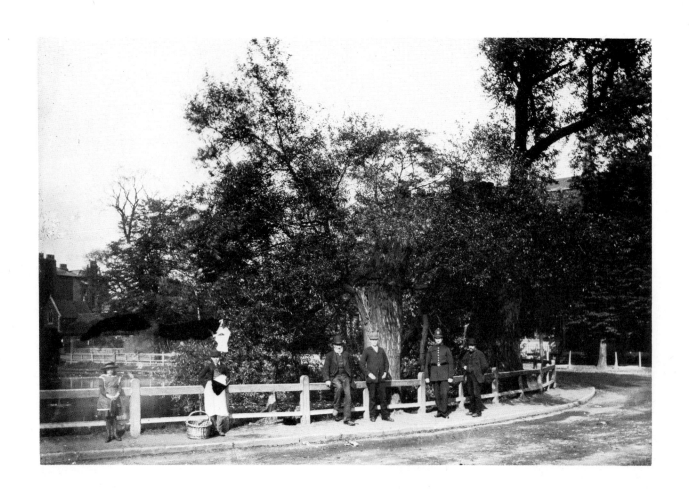

*Clapton Pond, at junction of Millfields Road and
Lower Clapton Road, looking east from the south
corner of Downs Road, Bishop Wood's Almshouses
in the left background. The village-like appearance
of the pond and its surroundings has long disappeared.
Date about 1885 in summer.*

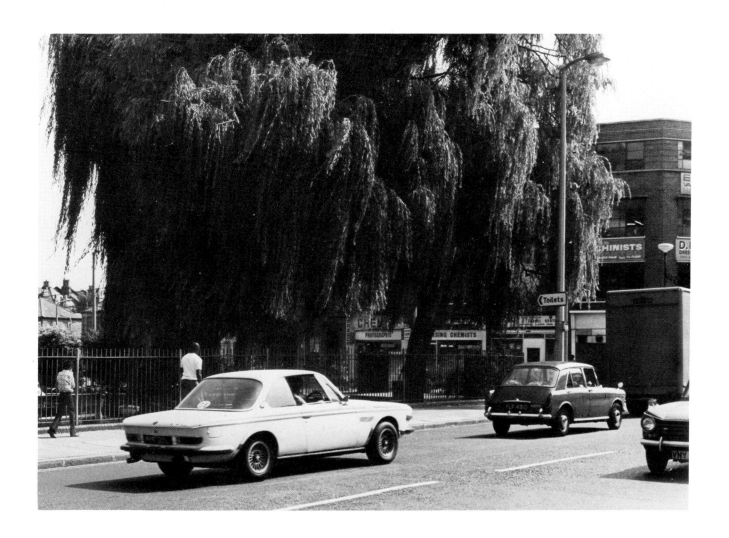

31

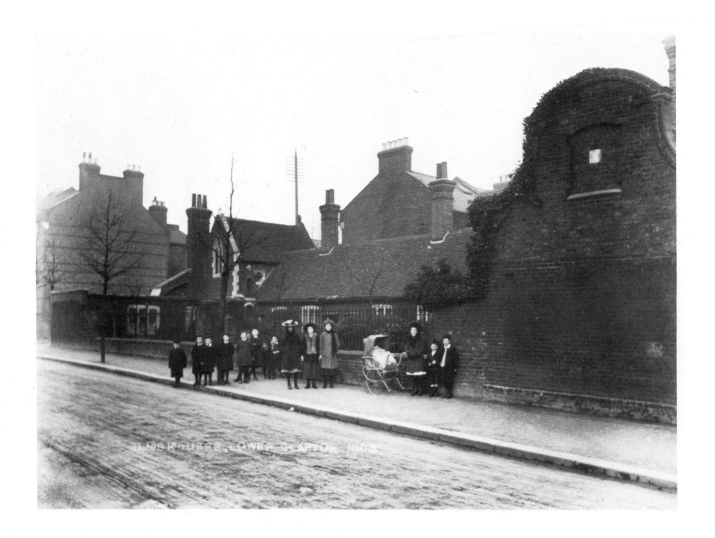

Bishop Wood's Almshouses, east side of Clapton Pond, looking north from opposite Pond House. Originally built in 1690 these have the smallest chapel in England, seating only ten people in two pews. They were restored in 1930 and are unchanged. Date 1906 in winter.

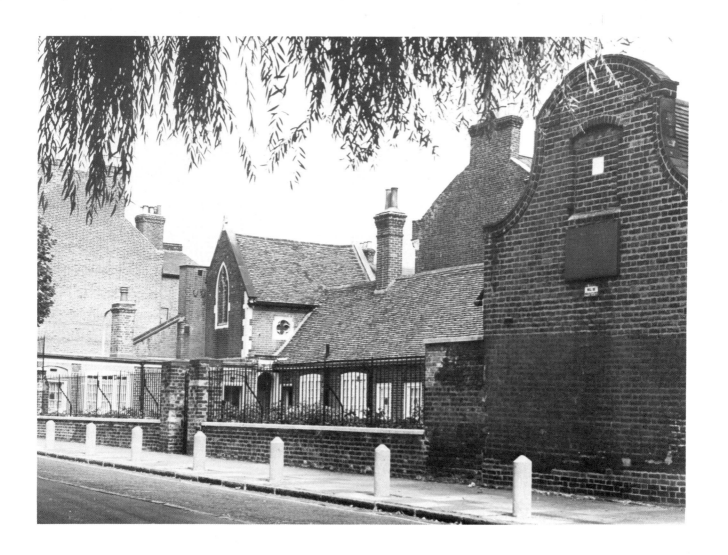

32

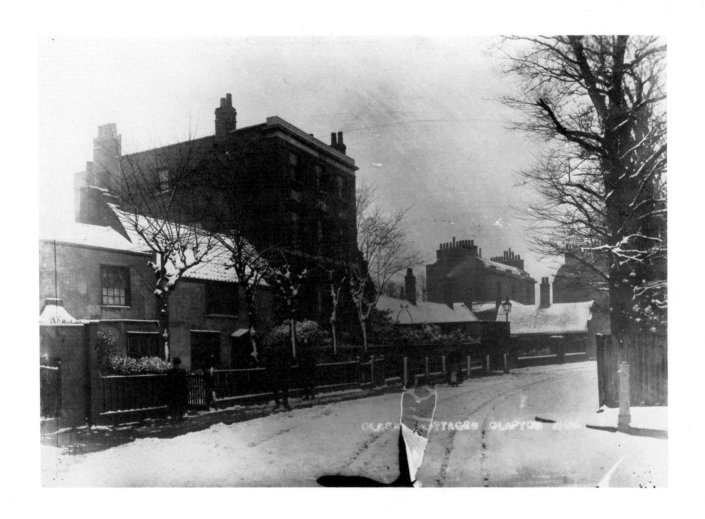

Clark's Cottages, left, and Bishop Wood's Almshouses, right, on the east side of Clapton Pond, looking south, taken during a snowy winter. The large house and cottages have long given way to the entrance to Newick Road and a row of bay-windowed, semi-basement houses extending north to Thistlewaite Road. Date 1884.

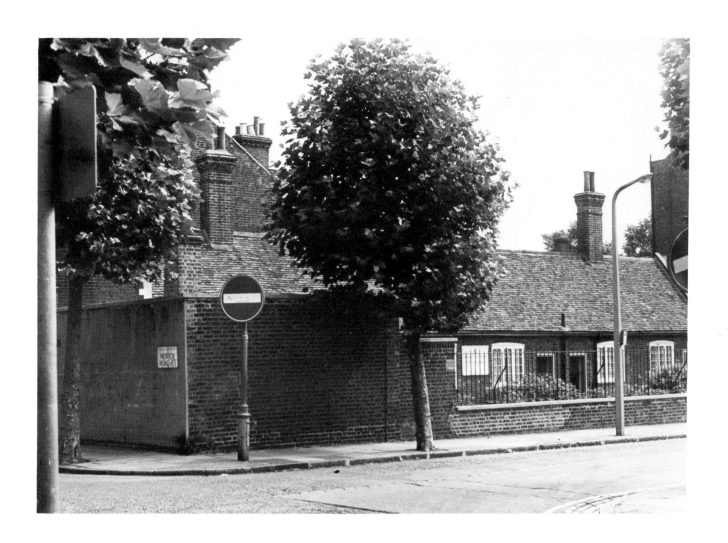

33

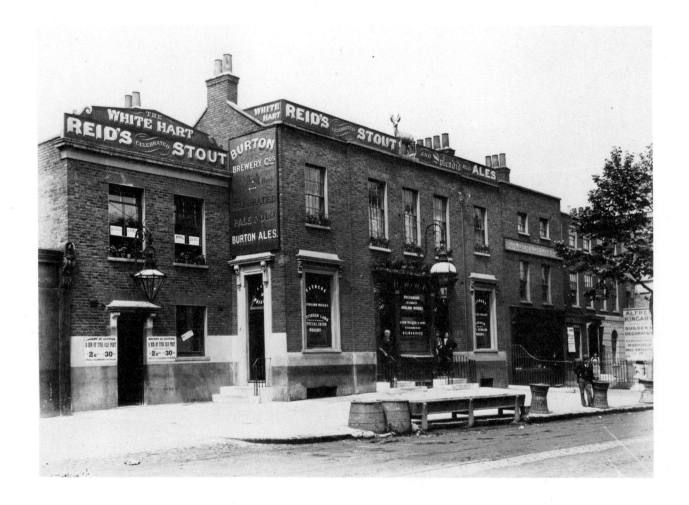

*The White Hart Public House, Lower Clapton Road,
a few doors south of Kenninghall Road, looking
north. Taken from the north corner of Thistlewaite
Road. The present building is completely different
and has a cupola at the top of the south corner.
The annexe on the left is now the Kenning Hall
Cinema. (The wicker baskets on the right contained
hay, and the barrels by the wooden water trough,
may have contained oats, for the dray horses when
beer was delivered.) Taken in the 1880's, summer.*

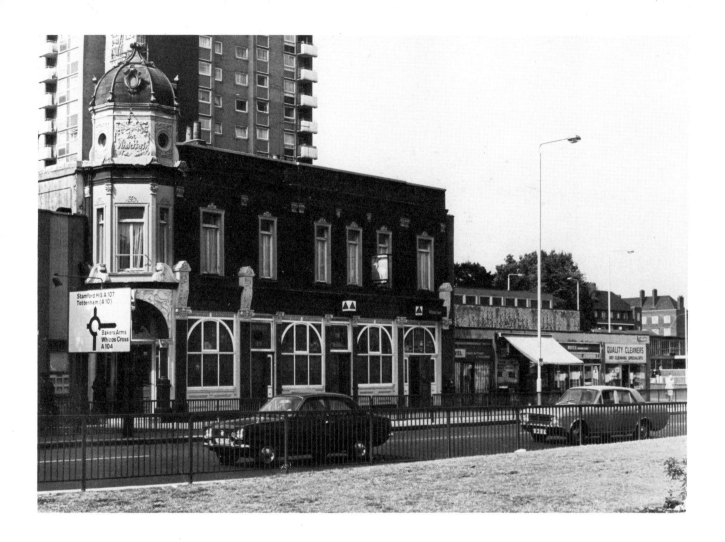

34

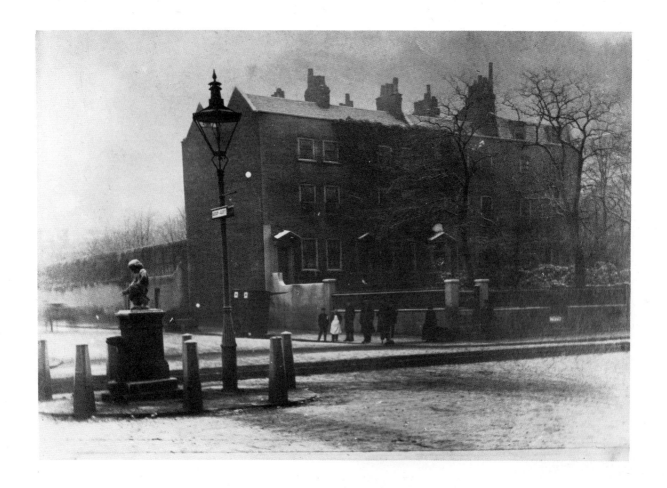

The north corner of Kenninghall Road and Upper Clapton Road, from the south corner of Lea Bridge Road. Behind the terrace of late eighteenth century houses stood the medieval Brooke House, together with which they were demolished after 1954 and replaced by the present Brooke House Comprehensive School. Date 1884 during a snowy winter.

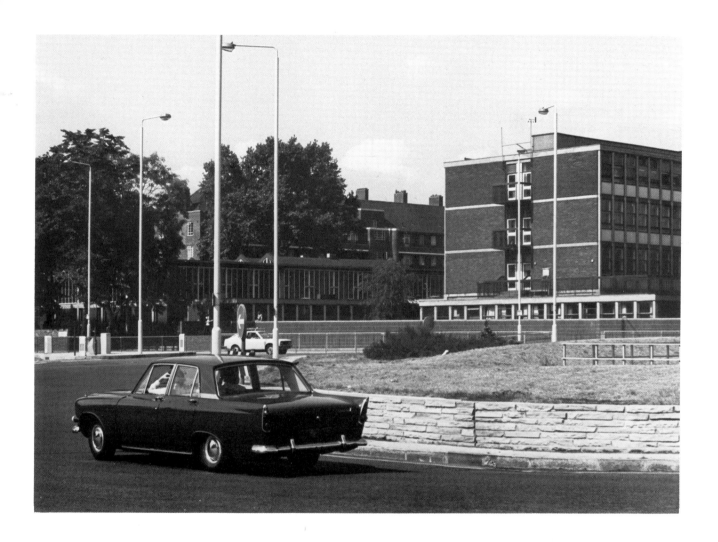

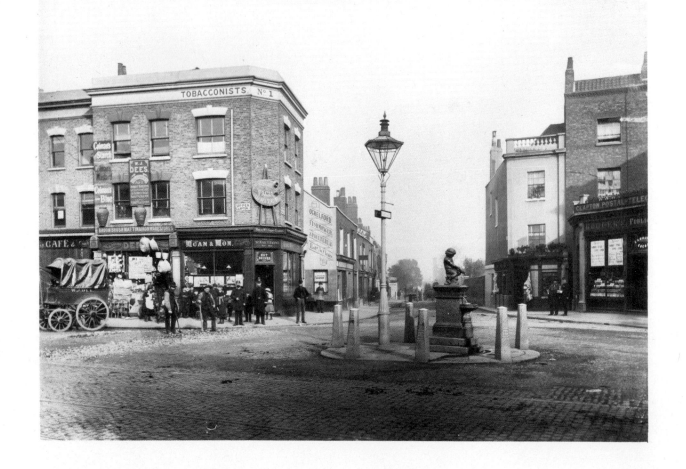

Lea Bridge Road, junction with Upper (left) and Lower (right) Clapton Roads, looking east from Kenninghall Road. The drinking fountain in the centre of the crossroads was transferred in 1908 to the corner of Amhurst and Rectory Roads. The statuette has long disappeared. Recently it has been suggested that it should be re-erected, with a newly designed statuette in the centre of the very large roundabout which now occupies the whole of this site. All the shops on both corners of Lea Bridge Road were demolished in constructing the round-about. Date early 1890's in the summer.

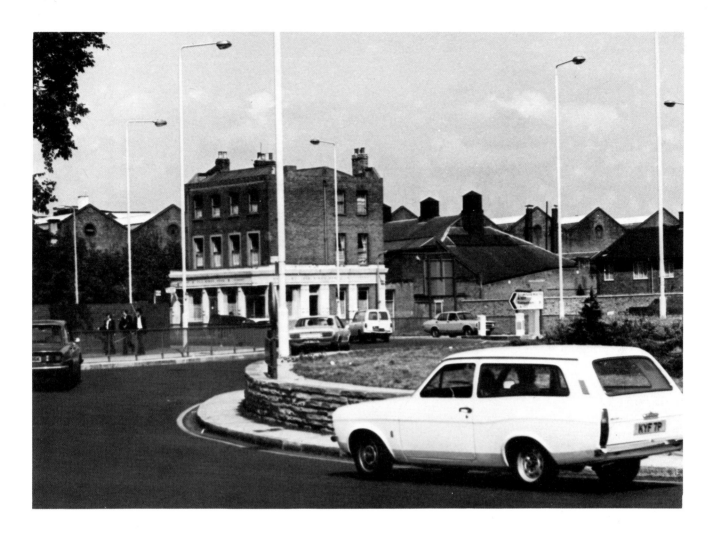

36

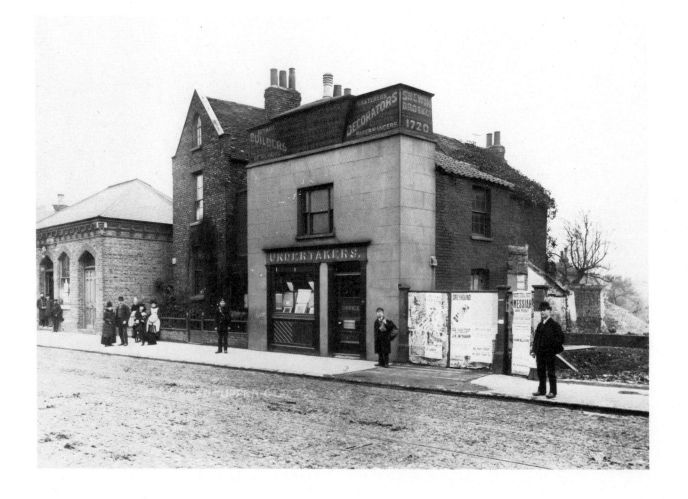

Clapton Station, Upper Clapton Road, looking north. The gabled house beside the station still exists, its lower storey obscured by a shop. The builder and undertaker has gone and some old shops occupy the site, forming the corner of Gunton Road which had then not been laid out. Date 1889 during April.

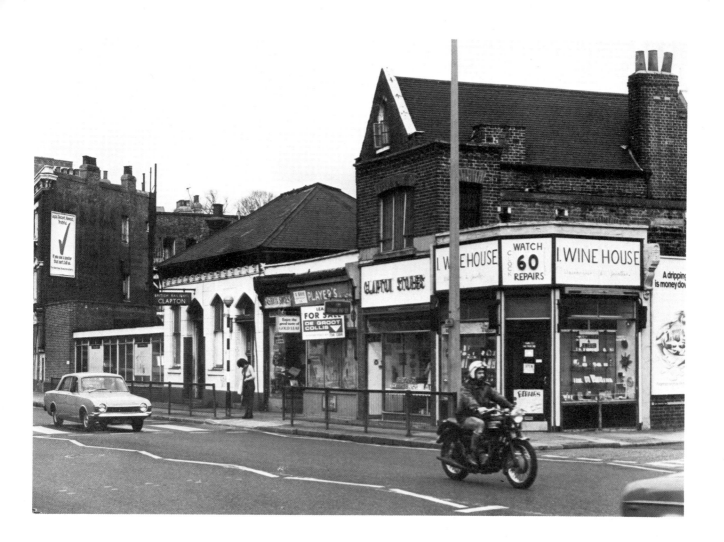

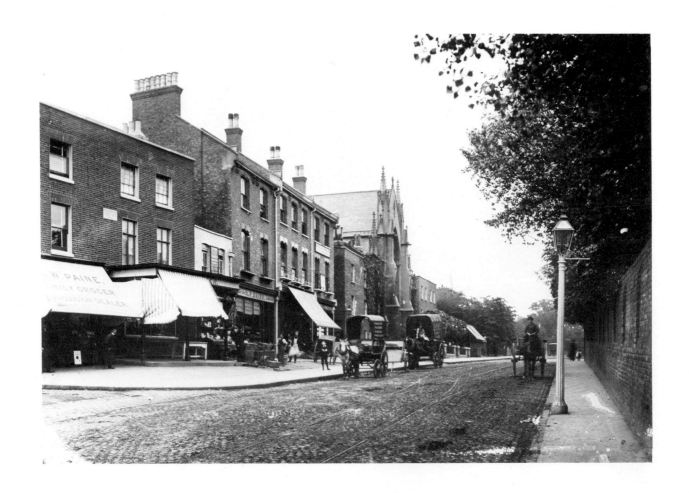

Upper Clapton Road, junction with Northwold Road (formerly Brook Street) looking north, Upper Clapton Congregational Church (now rebuilt and renamed United Reformed Church) in the centre of the picture. The wall on the right is that of the garden of the first house in Mount Pleasant Lane, now a row of shops; taken from near what is today The Mount. Date in the 1880's in the summer.

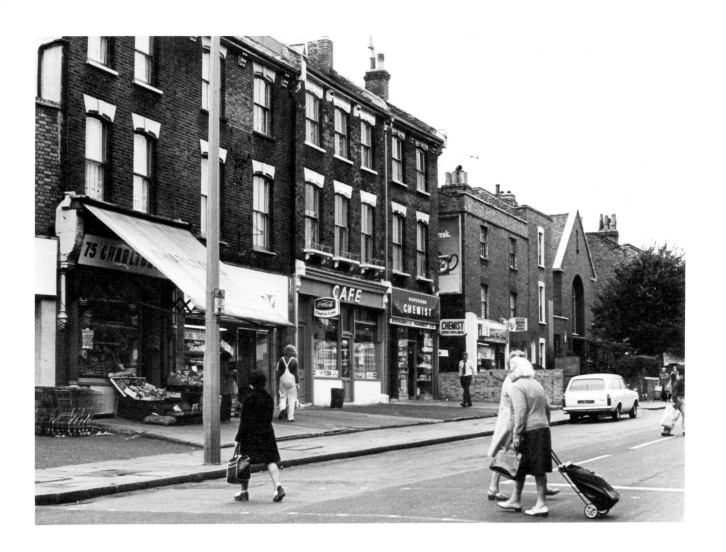

38

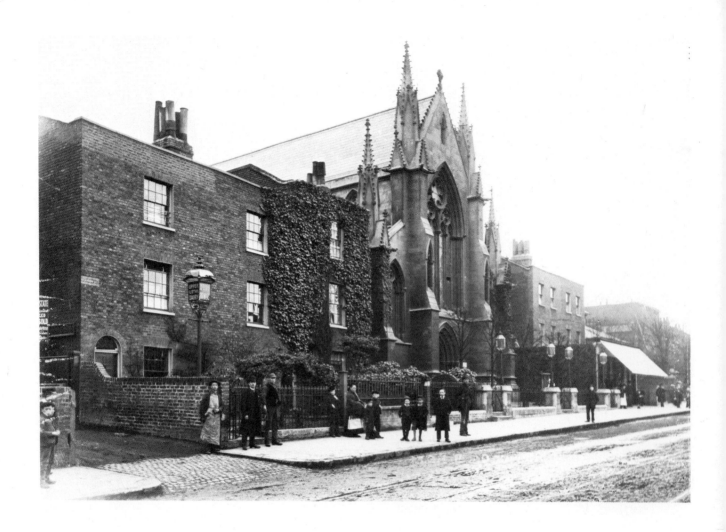

*Upper Clapton Congregation Church (now rebuilt
and renamed United Reformed Church) with the
Upper Clapton Dairy (Snewins) close by, taken from
a few yards further north than the previous picture
and probably later. Date in the 1880's.*

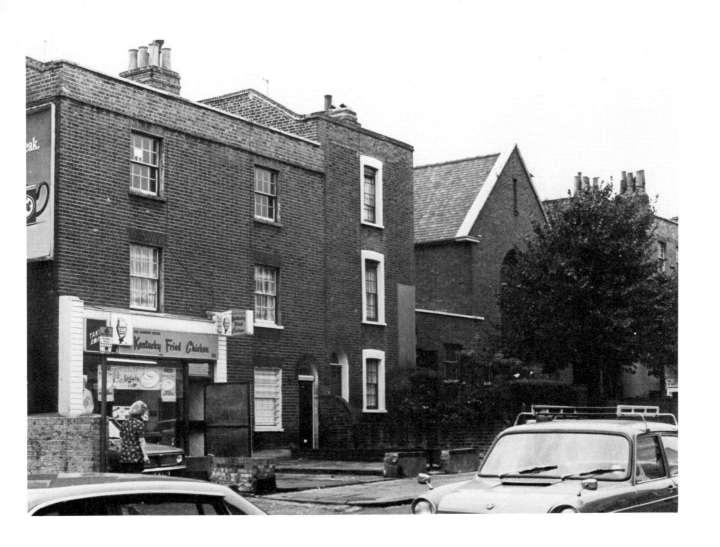

39

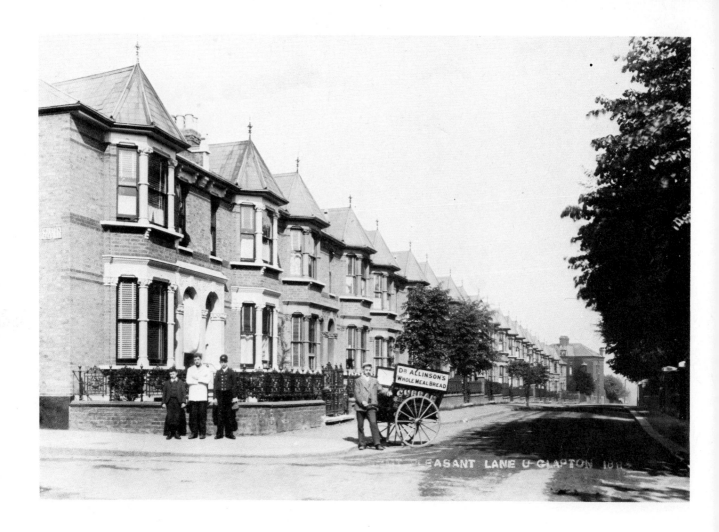

Mount Pleasant Lane, junction with Muston Road, looking east, from Upper Clapton Road. The houses on the left look exactly the same today except that the attractive iron railings have gone. The right side has been rebuilt with similar houses. Date 1884 in the summer.

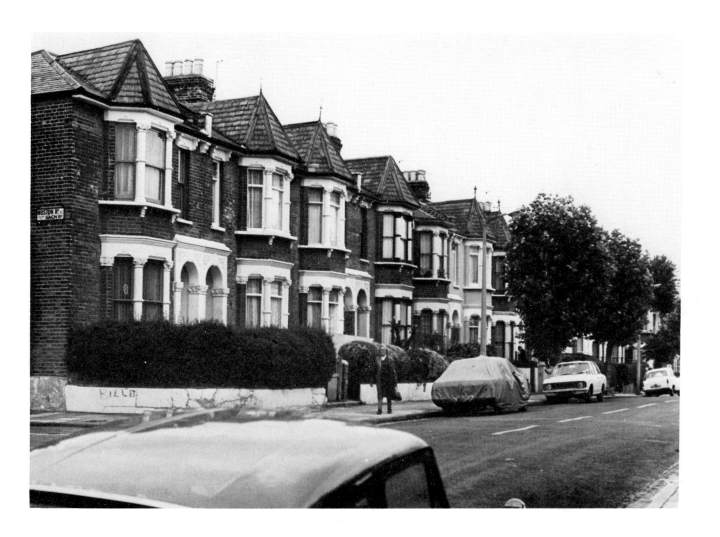

40

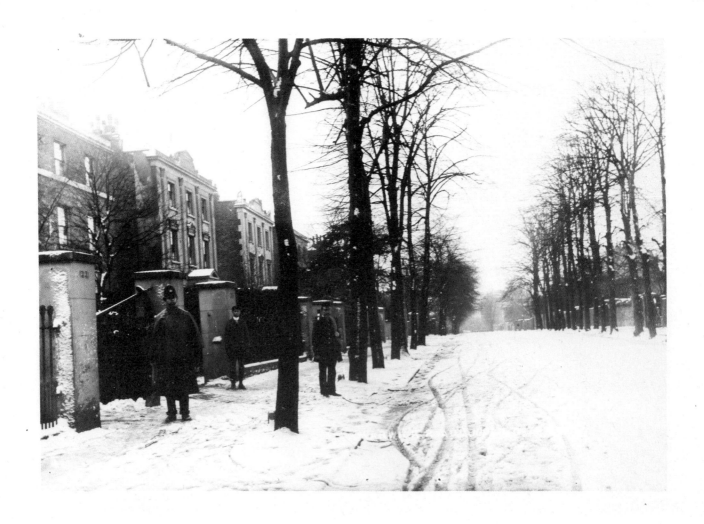

*Warwick Road (now Grove) looking west towards
Upper Clapton Road, taken about 500 yards from
the main road. Both sides of the road have been
rebuilt mainly with flats, but many of the trees
remain. Date 1884 in the winter.*

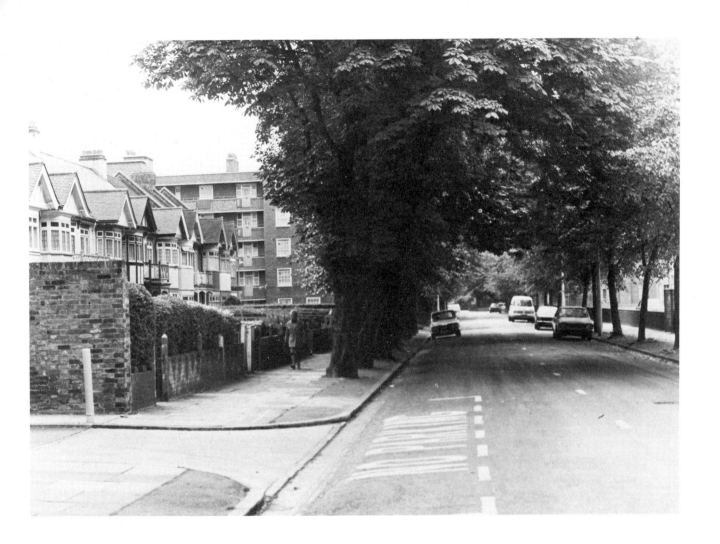

41

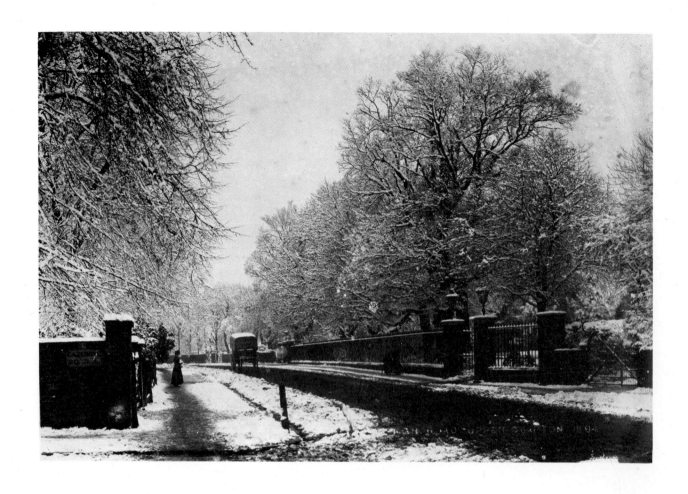

*Upper Clapton Road, junction with Cazenove Road
looking north, taken from the south corner of the
latter. Today this beautiful view is unrecognisable,
the right side of the road being built up with houses.
Date 1884 in the winter.*

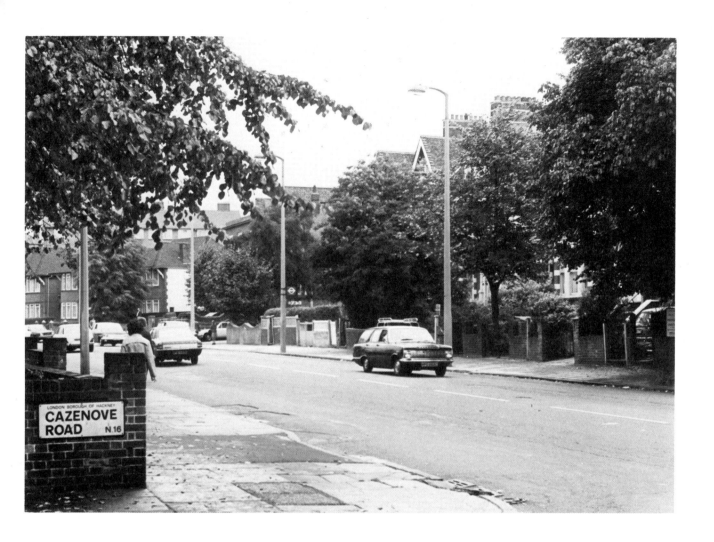

42

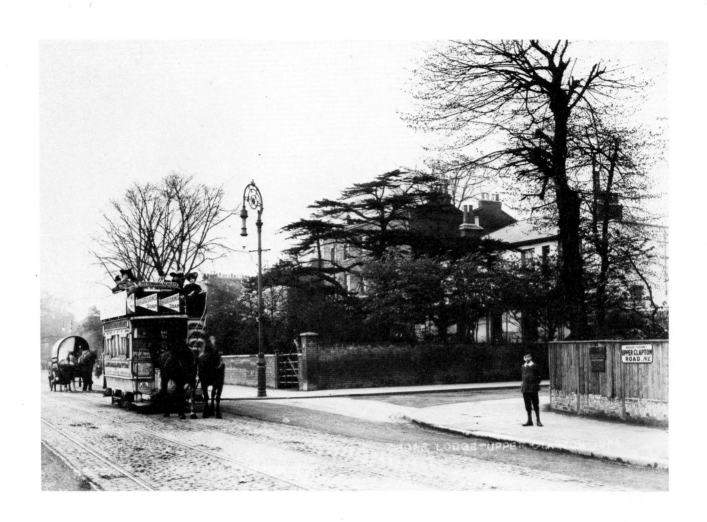

Upper Clapton Road, junction with Springfield,
looking north taken from what is now Filey Avenue.
The Lebanon cedar tree is still there and flourishing,
a tribute to the dust-free air of Upper Clapton.
Date 1904 in the spring.

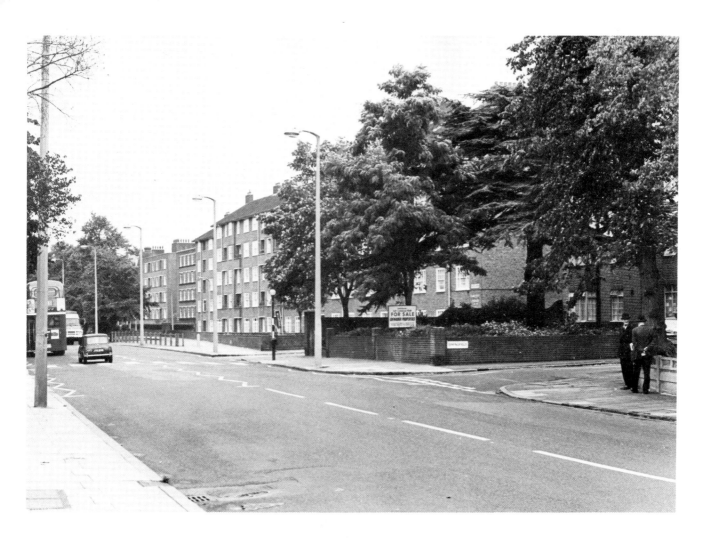

43

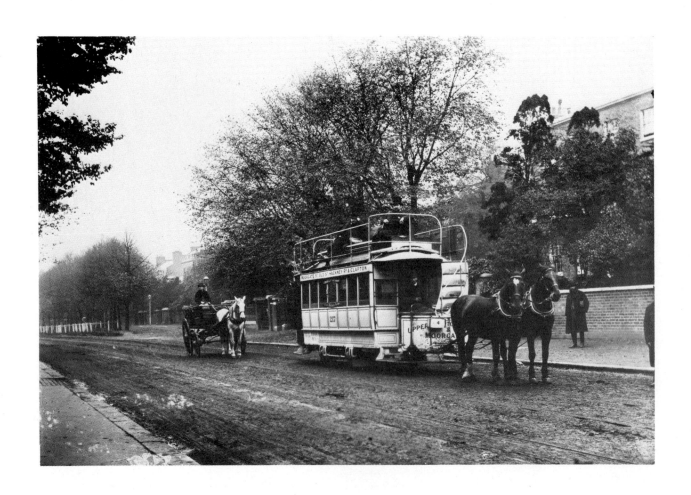

Upper Clapton Road, looking north, taken from the west side, on the corner of Chardmore Road. The beginning of Clapton Common is on the left. Flats replace the houses in the background. Date in the 1880's, in the summer.

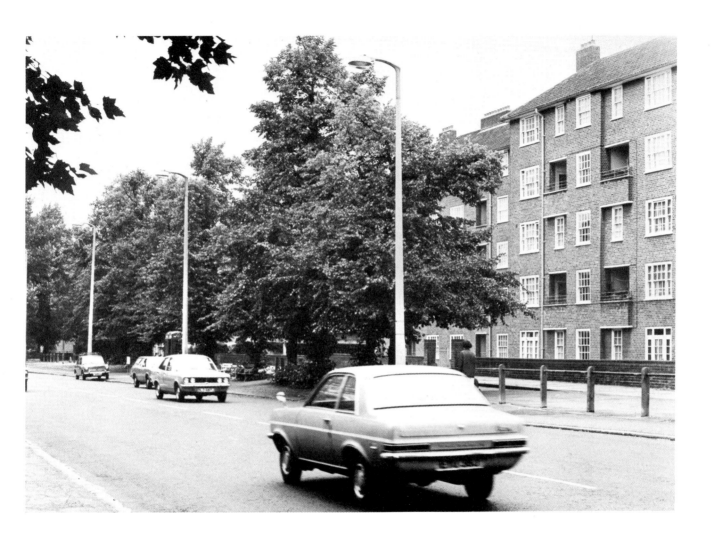

44

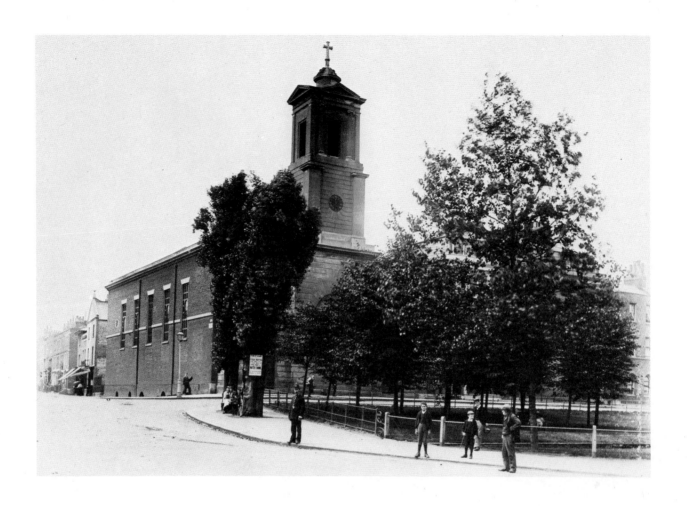

*St Thomas's Church at the corner of Upper Clapton
Road and Oldhill (formerly Hill) Street, looking
west, taken from Clapton Common. The body of
the church, destroyed in World War Two was rebuilt,
and re-opened in October 1958. The poster announces
a public meeting at the Town Hall to discuss a water
famine. Date 1893 in the summer.*

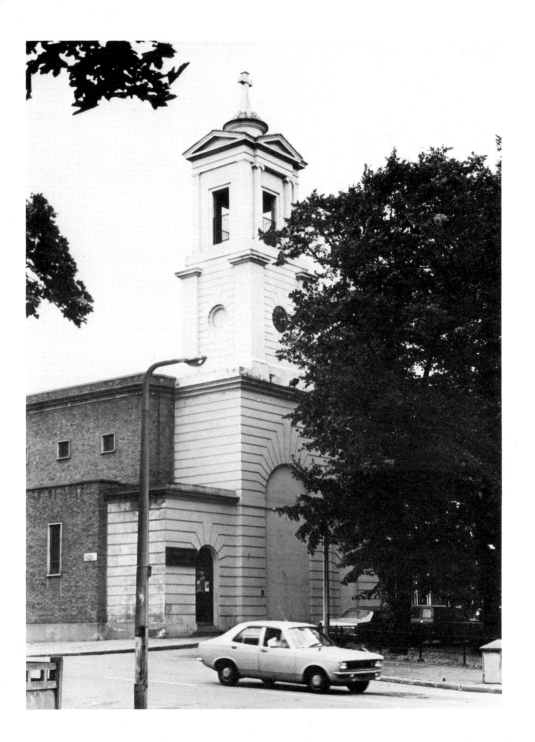

45

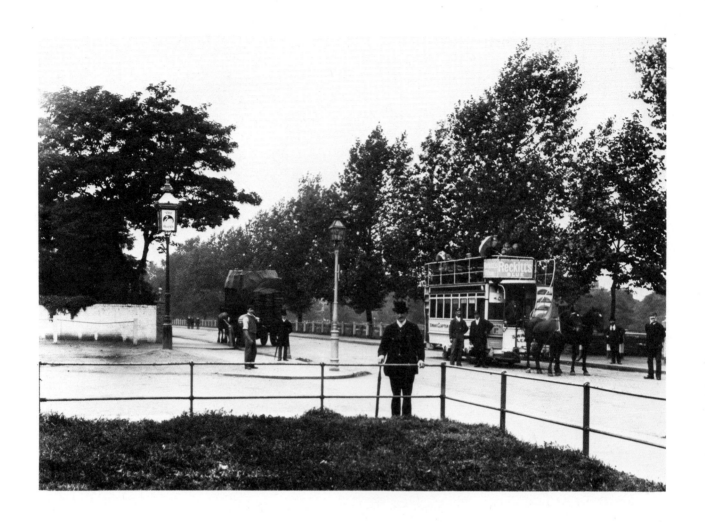

*Upper Clapton Road, junction with Braydon Road,
close to the Swan Hotel, then the tram terminus,
looking north; taken from the small green at the
north end of Clapton Terrace. The horse-tram ran
from the Swan to Lea Bridge Road for one penny.
Date probably in the 1880's in summer.*

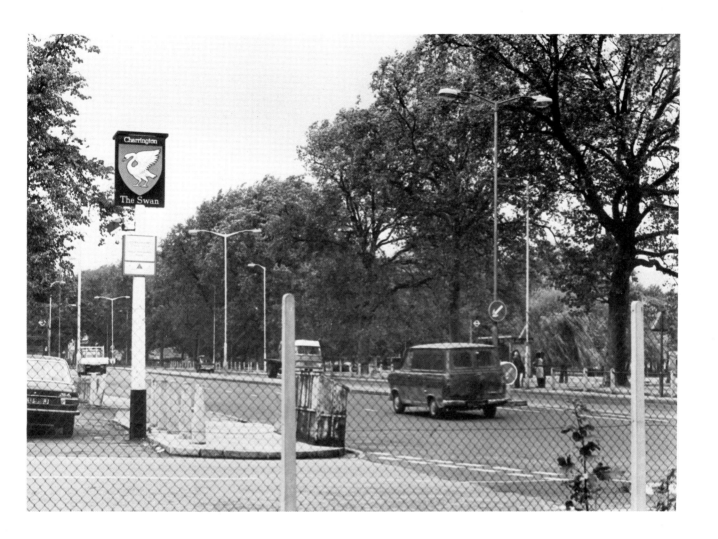

46

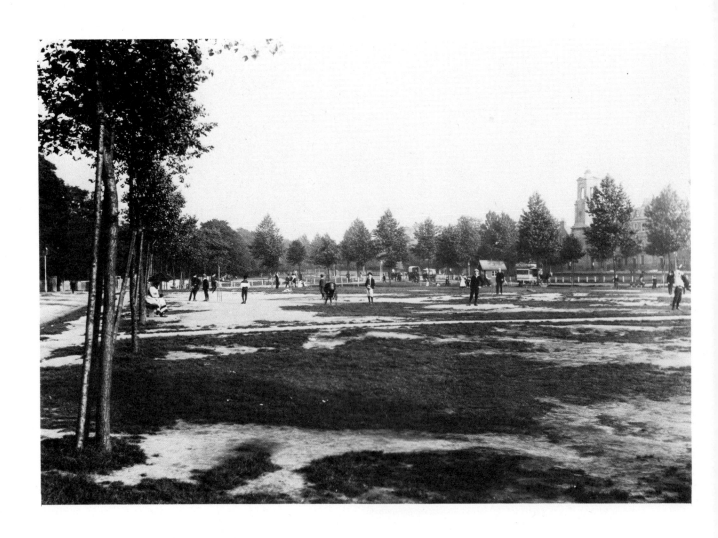

*Clapton Common taken from just south of the pond
and looking south toward St Thomas's Church.
There was a drought at the time as indicated by the
state of the grass. Date 1893 in the summer.*

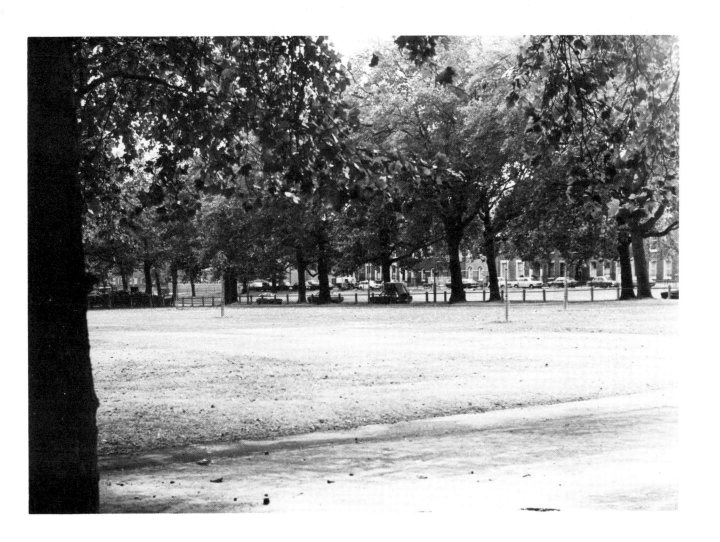

47

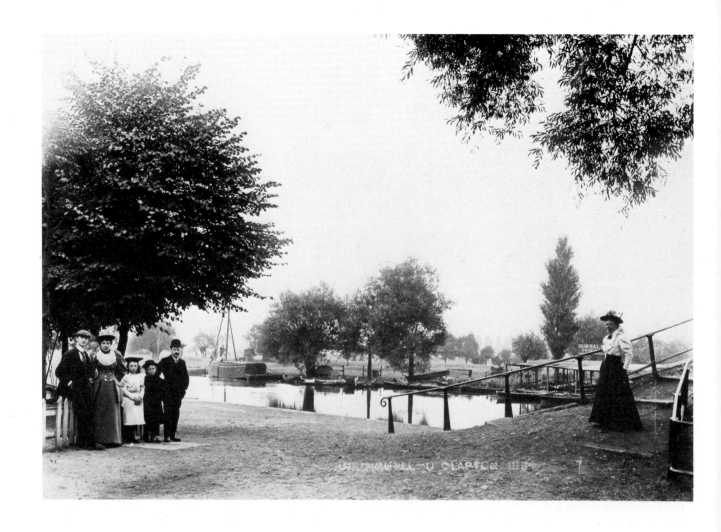

*Spring Hill, Upper Clapton, where it meets the
River Lea. The further side of the river is the site
of the present Walthamstow Reservoir. The
Lombardy poplar on the right and the lime tree on
the left are still there; taken from the bottom of
Spring Hill looking east. Date 1886 in the summer.*

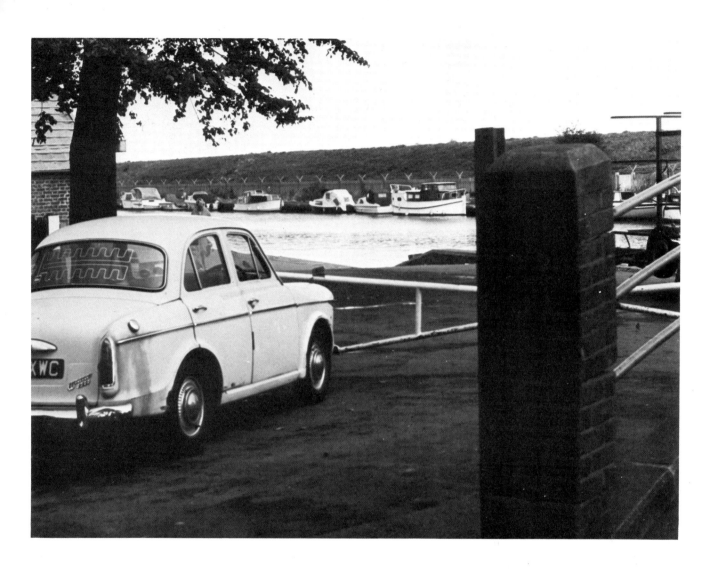

48

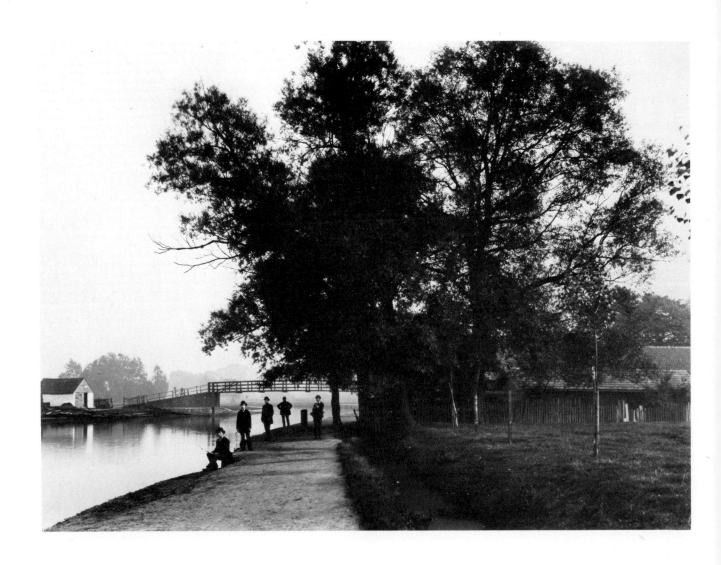

*The River Lea, with High Bridge, near Spring Hill,
taken from a few yards north of Spring Hill, looking
south. The low long building on the right still exists
but the wooden bridge has been replaced by a metal
one. Date 1886 in the summer.*

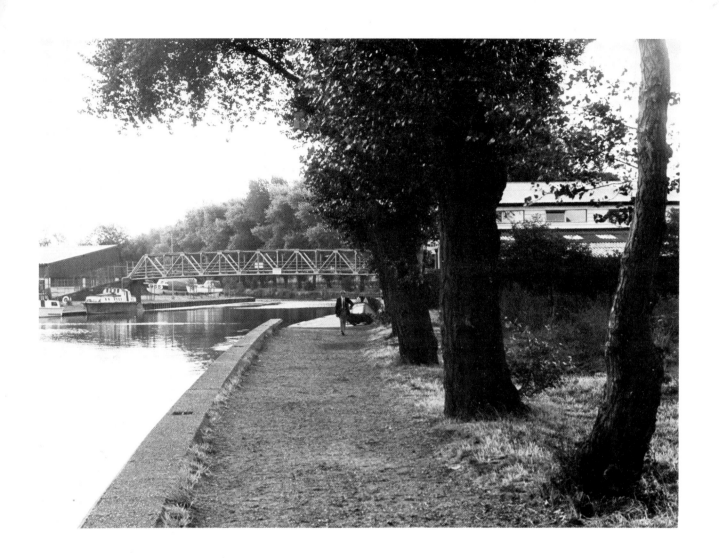

49

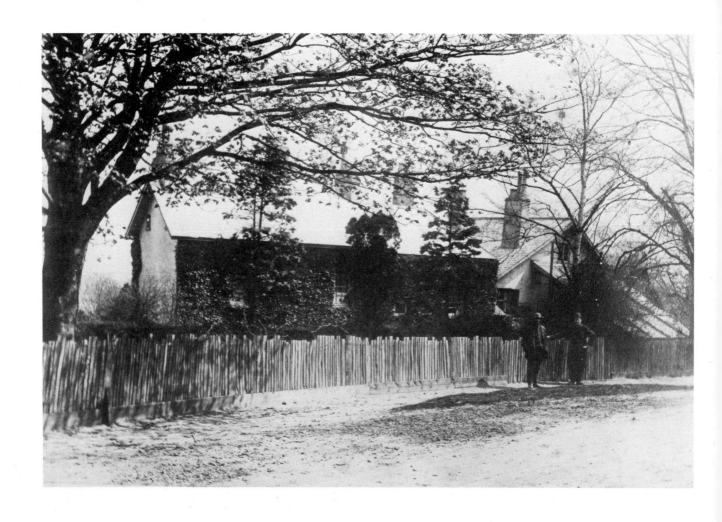

*Spring Lane, along the eastern boundary of
Springfield Park and a few yards north of the
Robin Hood Tavern, close to the River Lea which
ran behind the houses. Houses here were demolished
about ten years ago after flooding. Today a play
park is near the site. Date 1886 in the autumn.*

50

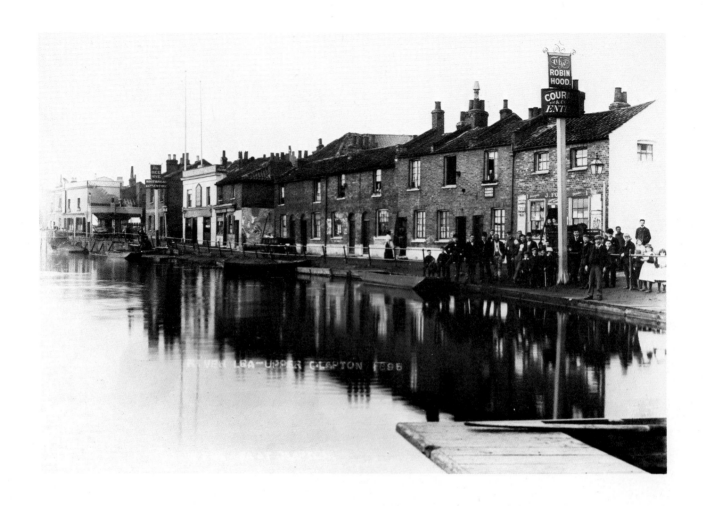

*The western bank of the River Lea, looking south
from the Robin Hood ferry. The row of shops and
small houses (on what was the corner of Little Hill)
are now replaced by flats. The Anchor and Hope
public house in the distance still remains. Date 1895
in the summer.*

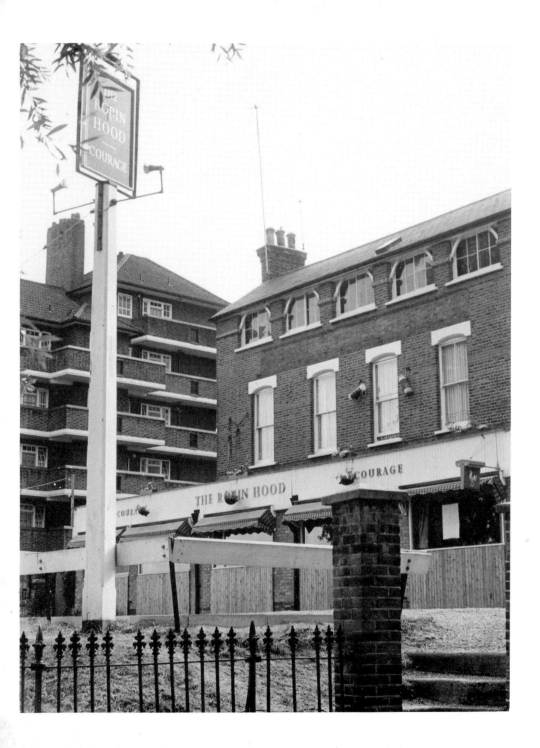

51

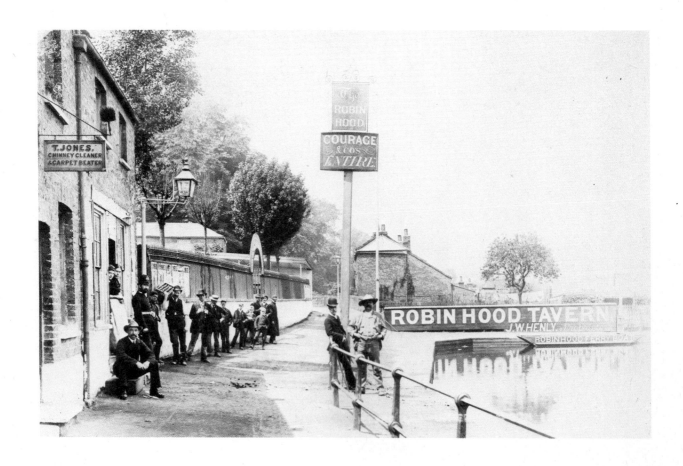

The Robin Hood ferry, looking north towards Big Hill and Spring Lane. The railings and wall in front of the public house are still intact but the wooden arch has gone. The ferry no longer exists. Date probably 1886 on a summer afternoon.

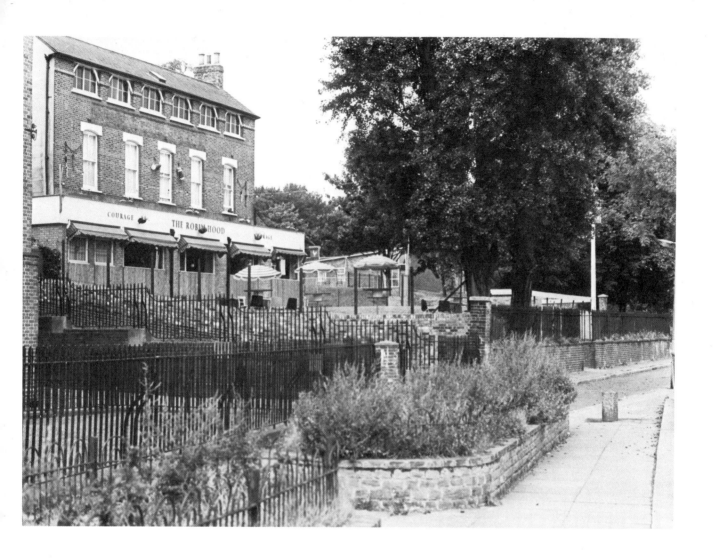

52

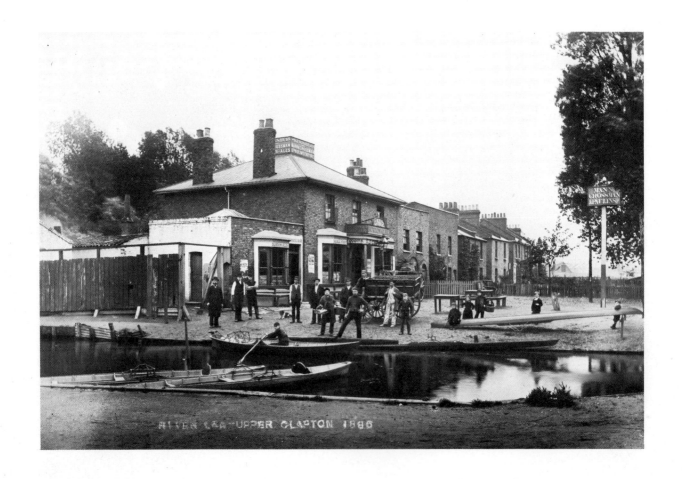

The King's Head Public House, at the end of Mount Pleasant Hill, backing on to the River Lea. The public house has been rebuilt; Lea Dock, in the foreground, filled in and covered with an open timber-storage shed; and the houses in the background replaced by a large wooden timber-storage shed. Both are owned by James Latham Ltd. Date 1886 in the summer.

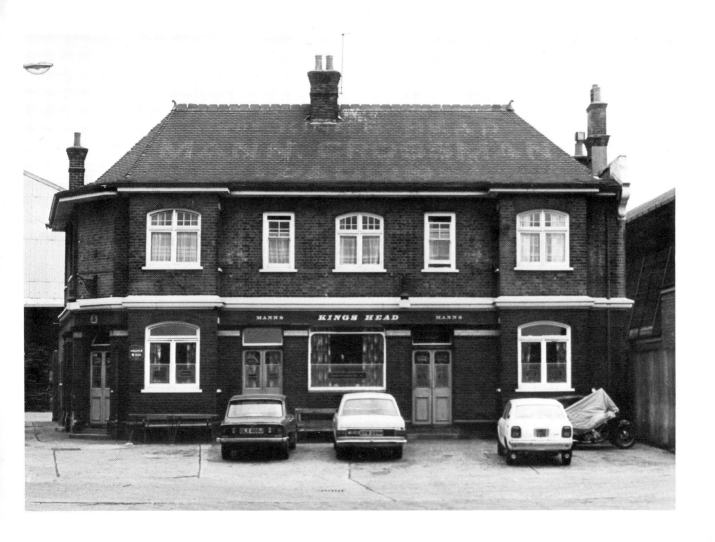

53

Centerprise Trust Ltd

Registered Charity No 266396
Centerprise is a community centre in Hackney,
based on a bookshop and coffee bar at
136/138 Kingsland High Street, London E8.
It is registered as an educational charity and is
administered by a management committee of
local people together with the paid workers in
the project.
As well as the bookshop and coffee bar,
Centerprise also houses a morning playgroup
for young children, an advice centre, an adult
reading centre where adults can learn to read,
and a community publishing service. There are
also several meeting rooms, including the
large basement, which can be used free of
charge by local organisations. Anyone who
lives or works in Hackney is welcome to
become involved in the works of Centerprise
and to become a member of the policy-making
co-operative which administers the project.
Because Centerprise is a non-statutory
organisation, it continually welcomes financial
support from organisations and individuals,
particularly on a local basis. We hope that if
people support the work that we do they will
help us carry on doing it.

Centerprise Publishing Project

The aims of the publishing side of Centerprise
are to provide free facilities and encouragement
to local people interested in writing. Three
kinds of writing have emerged as the most
welcomed: writing by children, individual
collections of poetry, and local autobiographies.
No payment is made to the writers whose
work is published, but they retain the copyright
to their work. The books are priced so that they
cover all their production costs, but they do
not make a profit; the intention is to keep
the prices as low as possible so as to encourage
larger sales.
We believe that publishing is a natural extension
of a community centre and that people have a
right to write about their lives and share them
with others around them.

Other Centerprise Publications

A Hackney Camera: 1883-1918
75p 60 pages 15p post
ISBN 0 903738 14 7

A unique collection of old photographs of
Hackney, many of them collected as the
result of a public appeal.

Years of Change
50p paperback 72 pages 15p post
ISBN 0 903738 07 4

The autobiography of a Hackney shoe-maker
covering the years 1900-1965. A unique
insight into nearly one hundred years of
working class life.

A Licence to Live: Scenes from a post-war working life in Hackney
50p paperback 76 pages 15p post
ISBN 0 903738 08 2

The autobiography of a local taxi-driver, from
his earliest childhood and evacuation, through
his 37 jobs to his present work. An important
piece of contemporary working class writing.

The Threepenny Doctor: Dr Jelley of Hackney
20p paperback 28 pages 10p post
ISBN 0 903738 11 2

A collection of stories about this famous
Hackney doctor of the early nineteen hundreds,
whose work for the poor was widely admired.
His eccentric behaviour is captured in these
reminiscences from fourteen elderly people,
transcribed from tape.

Rebels With A Cause
65p 96 pages 15p post

This is a history of the Hackney Trades Council
over the last 75 years, produced to coincide
with the anniversary exhibition and celebrations
in September 1975. A detailed, and stirring
account of trade union struggles in this borough,
illustrated with photographs.

A Hoxton Childhood
65p paperback 128 pages 15p post
ISBN 0 903738 02 3

Paperback edition of a book first published in
1969 and which achieved national acclaim
for its extraordinary evocation of East End
family life at the beginning of this century.

Vivian Usherwood: Poems
20p paperback 32 pages 10p post
ISBN 0 903738 09 0

A collection of peoms by a thirteen year old
boy from the West Indies about his friends,
his home and school.

Christine Gillies: Poems
10p paperback 20 pages 8p post
ISBN 0 903738 12 0

A collection of poems by a local young woman
— an early school leaver writing mainly about
relationships with others.

Home For Tea
15p paperback 32 pages 8p post
ISBN 0 903738 10 4

Collection of forty poems by a local woman,
mostly about her three young children.
Illustrated with a number of very fine line
drawings.

One Step Forward
20p paperback 24 pages 8p post
ISBN 0 903738 16 3

Collection of carefully written poems by a
local man who has worked in the printing
trade since leaving school. The poems show an
acknowledged influence from Keats, Hardy
and Robert Frost.

A map of the area in the 1870's

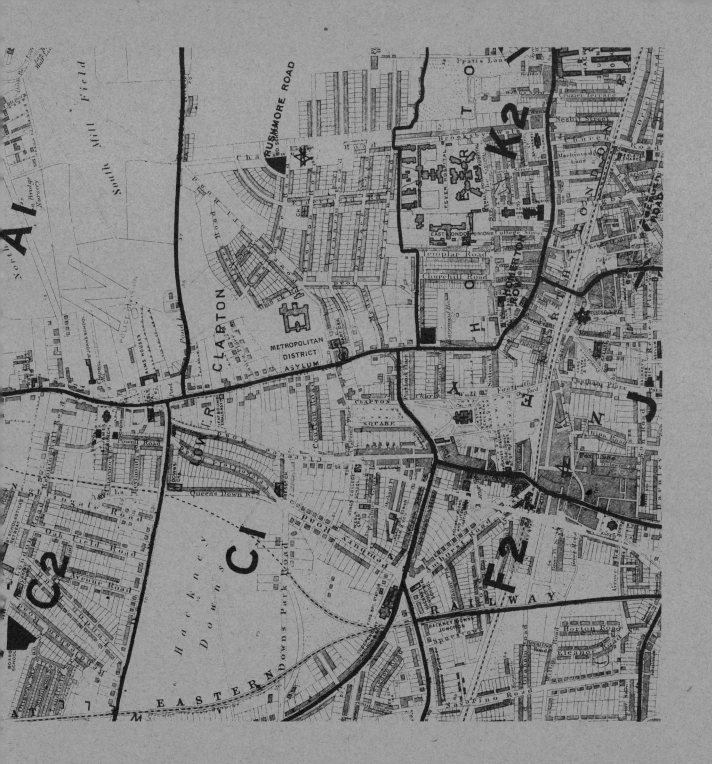